Gregory Martin

BRUEGEL

With 40 color plates

PARK SOUTH BOOKS
An imprint of
Publishers Marketing Enterprises Inc.
386 Park Avenue South
New York, New York 10016

Published by PARK SOUTH BOOKS
An imprint of Publishers Marketing Enterprises Inc.
386 Park Avenue South
New York, New York 10016

First published in the U.K. by
Thames and Hudson Ltd, London

© John Calmann and Cooper Ltd, 1978
This book was designed and produced by
John Calmann and Cooper Ltd, London

Reprinted 1985

Library of Congress Catalog Card Number: 84–61601

ISBN 0-917923-00-6

Printed in Hong Kong by Mandarin Offset Ltd

Introduction

PIETER BRUEGEL THE ELDER (active between *c.*1550/1 and 1569) is one of the most popular artists of all time and a national hero of twentieth-century Belgium some four centuries after his birth. In his lifetime he was patronized by his country's leading statesman and after his death most of his paintings were reunited by the Viennese Habsburgs. They were greatly admired by Rubens, another of the great artists of Flanders. His appeal has always been immensely wide, his pictures offering an astonishing variety of vividly intelligible concepts.

The huntsmen trudging homeward in the snow, the harvester asleep with his legs splayed out beneath a tree, the child licking food off its fingers, the gambler drawing his sword to fight with death, all these are the unforgettably vivid expressions of a genius who looked at life hard and portrayed it with profound wit. Judged by his contemporaries both as the greatest follower of Bosch (whose exotic fantasies he repeated with didactic purpose) and as a realist whose style was closer to nature than that of any of his contemporary fellow Flemings, Bruegel was to have a decisive impact on the development of landscape, seascape and genre painting. Although he died in 1569, it is difficult to imagine the art of seventeenth-century Holland without him.

Bruegel's life ended in mid-stream; his painted, extant *œuvre* amounts to less than fifty works; over a hundred prints designed by him are known and these too constitute an important aspect of his art. His career spanned some eighteen years, at least four of which were spent travelling. From then on (1555) back in his native land, he divided his activity between painting and designing prints, with the latter predominating at the start of his career and painting at the end. Preferring to paint on panel rather than on canvas and on a small rather than a large scale, probably only once, and then as an assistant, did he attempt life size. His paintings are crammed with detail and fully worked up; we see him as a slow, painstaking worker, assiduous as observer, prolific with ideas and rarely, if ever, repetitive.

He was first a landscape artist and lover of nature, being equally receptive to a Flemish hamlet snuggling among trees as to Alpine passes and panoramic views. Come winter or high summer or gloomy autumn evening, he could catch the sense of the seasons with a countryman's experience. He was a town lover too; and described both the Eternal City and hectic, Flemish urban life. From estuary and river views, he turned also to the sea, fascinated both by ships and storms. Traveller and adventurer, Bruegel was no stay-at-home, however devoted to his calling. Little wonder that of the few men that we know were his friends, one should have been the cartographer and geographer, Jacob Ortels.

After his love of nature, Bruegel was insatiably curious about his fellow human beings. In Flemish proverbs he was an expert, in children's games too, both of which he depicted in encyclopaedic detail. His travels in the countryside took in the life of the peasants, whose clothes and lifestyle he recorded with care. Apparently never interested in portraiture for its own sake, and little interested in bourgeois or high life, Bruegel was drawn to the exotic coarseness and outspoken attitudes of the peasantry, the poor and the outcast. His knowledge and sympathy were such that an early biographer

recorded that he was of peasant stock, an assertion that cannot be proved and today tends to be discounted.

Country weddings, village life and tradition were not the passion, in Bruegel's case, of a retiring escapist. His art shows that he had been the witness of the brutal aspects of contemporary life. The misery of the prisoner, the barbarity of judicial punishment, the fear of the condemned man, cowardice before the mob, the revolting havoc wrought by soldiers sent to search and destroy, he knew all this and did not hesitate to remind us of it. Wise and quiet, probably respected but essentially a private person, he watched, noted and then described both nature's beauty and man's passion and cruelty, never with sentimentality but always with a vital, convincing realism.

Bruegel was to retain this realism when he treated religious subjects. His *Massacre of the Innocents* has understandably, but perhaps wrongly, been interpreted as a direct comment on contemporary events. The increasingly Draconian measures of King Philip II of Spain, ruler of the Netherlands, to counter the Reformation made religious questions a matter of life or torture and death. Probably a deeply religious man, and certainly possessed of a profound Christian sense of right and wrong, Bruegel's religious stand-point is not clear, but while there is evidence of Protestant sympathy and of a fear of official displeasure at work that he had retained in his studio, there is nothing to suggest that he was ever persecuted, and he never chose exile in order to practise his faith.

His attitude is likely to have been similar to that earlier adopted by Erasmus, and to have been inspired by the Christian humanist ethic of the Antwerp poet and engraver, Dierick Coornhert. The Libertinist movement, ignored by officialdom, taught a message of salvation dependent on the individual's attitude to God, exclusive of religious ceremony. No doubt Bruegel outwardly conformed, but his real credo was of toleration that set contemporary rabbi, priest and Protestant churchman on equal footing. Such a group he once depicted in debate with a Bible remaining shut nearby.

Not a great deal is known about Bruegel's life. He was accorded a lengthy entry in Carel van Mander's *Schilder-Boeck*, published some thirty-five years after his death. The author, who greatly admired his subject, is likely to have obtained information from one or both of Bruegel's two sons. His biography is often accurate, although neither he nor modern research have been able to establish when Bruegel was born or precisely where.

His origins must have been obscure or at least his family not worthy of note. Van Mander placed his birth in a mythical village called Bruegel not far from Breda. However, in his own lifetime, Bruegel was described as a native of Breda and this statement by Guicciardini, otherwise unproven, deserves respect. Van Mander correctly states that he became a master in the Antwerp guild of St Luke in 1551, having been a pupil of Pieter Coecke van Aelst. His master, whose last years were spent in Brussels, died in 1550; recent research has shown that Bruegel worked, in 1550–51, as an assistant to Pieter Balten in the execution of an altarpiece for the church of St Rombouts in Malines. Bruegel should have been well equipped for such a task, as his master had been one of the leading figure painters of his day, leaning heavily on the masters of the Italian High Renaissance.

After his election as master in the Antwerp guild, Bruegel set out on the customary journey to Italy. His time south of the Alps is fairly well documented. Probably in his early or middle twenties when he set out, he travelled via Lyons and through eastern France and then apparently straight towards southern Italy to arrive in Reggio in Calabria in time to witness the Turkish attack there in 1552. A drawing – his earliest extant work – shows

the town ablaze. In the following year he was in Rome, where the first testimony to his budding genius is provided by his association with the celebrated miniaturist Giulio Clovio, some thirty years his senior. The two collaborated in the execution of a miniature which was noted, along with other works by Bruegel, in an inventory of Clovio's estate drawn up in 1577.

The young landscape painter did not hurry home as he had hurried south; existing drawings establish that he wandered, probably in the summer of 1554, through the Alps, taking the St Gotthard pass into the Tyrol to explore as far as Innsbruck. By the following year he had returned to Antwerp, his mind full not so much of Rome but of the mountains and valleys he traversed on his carefree way home. As van Mander recorded it was said of him that 'When he travelled through the Alps, he swallowed all the mountains and rocks, and spat them out again, after his return, on to his canvases and panels.' (See F. Grossmann, *Pieter Bruegel Complete Edition of the Paintings*, Phaidon, 1973, p. 9.) It was drawings made during his travels that formed the basis of his partnership with the leading engraver and publisher in Antwerp of the time, Hieronymus Cock. In 1555 he published a series of landscape views by Bruegel, and thus was launched a long and important association.

Patenier had made Antwerp an artistic centre notable for its landscape painters. He established a tradition that was to be sustained by Herri met de Bles, Lucas Gassel (in Brussels), Cornelis Massys and then by Matthys and his brother Hieronymus Cock. Bruegel's early interest in landscape is thus to be understood in the light of the tradition of the city in which he worked and by the predilections of his immediate associates. He was to add new, vital blood to this tradition and point out the way not only for Joos de Momper, but also for his son Jan Bruegel and for Rubens himself.

Cock's interests were not confined to landscape. He also made engravings after Hieronymus Bosch, whose fantastic, frightening scenes of Hell were still being repeated in Antwerp at the time of Bruegel's return there by Jan Mandyn for one, who was the master of Bruegel's likely companion on his journey to Italy, Martin de Vos. Bosch had died in 1516 at s'Hertogenbosch; he was to be greatly admired by King Philip II, who in 1555 received from his father Charles V his Burgundian possessions and so became the ruler of the Netherlands. It is therefore not surprising that Bruegel, too, early turned to the obscure, powerful genius of Bosch, whose influence was to prove profound, both moulding his figure style and populating his imagination.

Bosch's imagery is first evident in the print *Big Fish Eat Little Fish*, and the series of the *Seven Deadly Sins*, the first of which was published in 1556. At about this time has recently been dated the *Adoration of the Magi* in Brussels, painted in tempera on canvas – a technique he may have learnt from Pieter Coecke as a means of preparing cartoons for tapestries. The angled placing of the stable recalls that in Bosch's *Adoration* at Lisbon. The size of the canvas was ambitiously large, and Bruegel had learnt sufficiently from Bosch to include a large number of figures on the small scale that he was long to favour. The large-scale, 'Romanizing' figure painters then active in Antwerp, Floris for example, had little to offer him; on the other hand it is likely that Pieter Aertsen, with his interest in the everyday both for its own sake and as setting for biblical events, helped him to find his way.

Van Mander records that Bruegel 'often went out into the country to see the peasants at their fairs and weddings' (Grossmann, *op. cit.*); he must have drawn *The Fair at Hoboken* in 1559 after one of these trips. Nine years earlier Aertsen had also depicted a country fair, although he had concentrated on the bourgeois participants in the foreground. But the scale of the figures and the sure but calligraphic handling of the brush would have pleased the young

Bruegel, who, in the same year as he visited Hoboken, painted his two first masterpieces about contemporary Flemish life and customs – the *Netherlandish Proverbs* (*plate 3*) and the *Fight between Carnival and Lent* (*plate 1*). The following year he executed the *Children's Games* (*plate 5*) and thus already could lay claim to being a master of Flemish folklore.

The sheer volume of erudition and the vividly imaginative expression of it displayed in the three panels are extraordinary. These works are to be read like Bosch's *Garden of Earthly Delights*. There is not a blank or flaccid passage; Bruegel densely transmits all his visual wit and spills out the notes and jottings he had made since his return to his native land.

Bruegel paid his last overt tribute to Bosch in two paintings, both of which were probably finished three years later – the *Dulle Griet* (*plate 11*) and *Fall of the Rebel Angels* (*plate 9*). In the latter, the rebel angels have already been transformed into exotically gruesome biological quirks; they tumble – Lucifer's swarm – driven by the Archangel Michael to populate a Boschian hell. The old hag, Dulle Griet, the personification of covetousness, is ready even to enter hell in pursuit of her obsession. She storms, laden with baskets and sword in hand, into a crazy fairground hell inhabited by demons and fighting, greedy women.

Bruegel here comes to closer grip with his subject matter by lowering his point of vision and meeting his subject not from above but at eye-level. Perhaps slightly earlier, therefore, is *The Triumph of Death* (*plate 13*), seen from above and from more of a distance. Death strikes a party of soldiers and their women, to whom is revealed his vast army and the bleak landscape of his gruesome empire. Two lovers remain unaware of their fate, as their male companions choose to fight, while their lady friends are hustled off, like the king and prelate who are helped on their way by skeletons.

These three works are the grimmest, most foreboding and apocalyptic in Bruegel's *œuvre*. It is largely but not entirely coincidental that they were executed at a time of growing religious tension in Antwerp, where Protestants now numbered some 16,000 and from whence in 1562 the printer Christoffel Plantin was forced to flee to escape charges of heresy. In the same year, Bruegel himself left the city that was soon to see the full rigours of Philip II's anti-Protestant policy. He visited Amsterdam, and then settled in Brussels, the seat of the established government of the country, where in the following year he married the daughter of his erstwhile master, Pieter Coecke. Van Mander explains his departure from Antwerp in the light of this event, relating that his mother-in-law insisted on the move to separate him from the domestic with whom (van Mander implies) he hitherto had lived on intimate terms.

His setting up home in Brussels was not to mean a complete break in his professional life. No doubt it brought him into closer contact with Cardinal Granvelle, the President of the Council of State. But only after 1563 does documentary evidence exist for his friendship with Ortels and the Antwerp financier Jonghelinck, whose brother, a sculptor, had also settled in Brussels. And while his working relationship with Cock was to become less regular, one of his first tasks was to complete the series of designs for engravings of battleships and seascapes. Associated with the series should be the picture of *The View of Naples* (*plate 7*); this work and the prints constitute the real foundation of the tradition of seascape art in the Netherlands.

The engraved portraits of ships would inspire a sailor's confidence and provide a sharp contrast to the disturbing masterpieces executed towards the end of his Antwerp period. That contrast, which demonstrates his versatility, prepares us for the *Flight into Egypt*, one of the first paintings executed in Brussels, and probably for Cardinal Granvelle. Here, as if to compensate for his

new surroundings, Bruegel returned to his earlier love of Patenier, just as he was, in the same year, 1563, to recapitulate a theme first executed in miniature in Rome when he painted *The Tower of Babel* (*plate 16*). Memories of Rome are evident in the aqueduct that surrounds Babel and in the architecture of the tower itself, which twists hopelessly heavenwards and is reminiscent of the Colosseum. In this parody of man's vanity, Nimrod, who visits his stonemasons, has the same features as the dying king in *The Triumph of Death*.

Reminiscent of that work too is the wide landscape setting chosen for the *Procession to Calvary* (*plate 17*), in which the grief-stricken Maries and St John are etched out like a medieval sculpture to perform the role of a Greek chorus interpreting the tragedy unfolding beyond. Christ wears his traditional robe as he falls beneath the Cross, but the tragedy is set as a contemporary procession to the gallows outside the city confines. The *Numbering at Bethlehem* (*plate 25*), the *Massacre of the Innocents* (*plate 28*) and the *Conversion of St Paul* (*plate 29*) were also seen in contemporary terms, the first two in snow-covered Flemish hamlets and the third dramatically on an Alpine pass.

Bruegel was to establish himself as the first master of winter landscapes, taking up the theme where Netherlandish miniaturists had earlier left off, most notably in *January* (*plate 19*), the first of a series depicting the months painted for his Antwerp admirer, Jonghelinck. No detail seems extraneous in this high point of Bruegel's *œuvre* and of European painting: from the bird wheeling against the sky to the tiny figures on the frozen ponds far below, this jigsaw of detail has been assembled with inspired devotion. While black and cold white dominates in *January*, hot yellow and green are the keynotes for *August* (*plate 23*). Whereas early in the year the huntsmen had trudged homewards, now in high summer the peasants take a noon break from harvesting. Food again is the focal point for the peasants in their unending tryst with nature.

With *January*, the *Wedding Feast* (*plate 33*) must rank as Bruegel's most popular work. From the outsize makeshift tray to the basket of earthenware pitchers is encompassed a profound knowledge and understanding of peasant life and, in the gesture of the guest handing out the food, thus directing our attention to the bride, a high degree of formal wit and originality. Here and in *The Peasant Dance* (*plate 34*), Bruegel once again seems to reconsider the work of Aertsen. Just as he had earlier (with the help of Bosch) given new life to Aertsen's country scenes so now he injects into Aertsen's nearly lifesize market and kitchen scenes a new spirit of vivacity and daring poetry.

Some twenty-five extant paintings were executed by Bruegel in his last nine years, spent in Brussels, and others are known to have been painted, so his output and activity were intense. But we know little about his life, other than the fact that he fathered two sons, maintained contact with his admirers in Antwerp and won recognition from his newly adopted city in the form of a commission from the City Council to commemorate the opening of the Antwerp–Brussels canal. In 1569, the Council was also to exempt him from the duty of housing Spanish soldiers and offered him a grant to enable him to pursue his art. This may have been a gesture of help to an already ailing man; Bruegel was to die later in the same year.

He bequeathed to his wife *The Magpie on the Gallows* (*plate 39*); according to van Mander that bird symbolized 'the gossips whom he would deliver to the gallows' (Grossmann, *op. cit.*). This late work expressed the chief passions and concerns of his art and spiritual life: a love of nature, a love for peasant life and a Christian's constant awareness of death and Christ's sacrifice. In the gorgeous sunset and the dance of the peasants beneath the gallows there seems expressed a message of hope and joy in the presence of death.

1. *The Fight between Carnival and Lent*

Signed and dated 1559. $46\frac{1}{2} \times 64\frac{3}{4}$in (118 × 164·5cm)

Bruegel uses a theme from the theatre, the fight between Carnival and Lent, to point the contrast between two sides of contemporary life, the one religious, stemming from the church, the other abandoned, inspired by the inn. The setting is a town square; well-behaved children and churchgoers giving alms make up meagre Lent's cortège; opposite her is obese Carnival astride a barrel of beer followed by a troop of masqued revellers emerging from the inn. The scene is a busy one; Bruegel is already the historian of everyday life.

Vienna, Kunsthistorisches Museum

All pictures reproduced in this book are painted on panel unless otherwise stated.

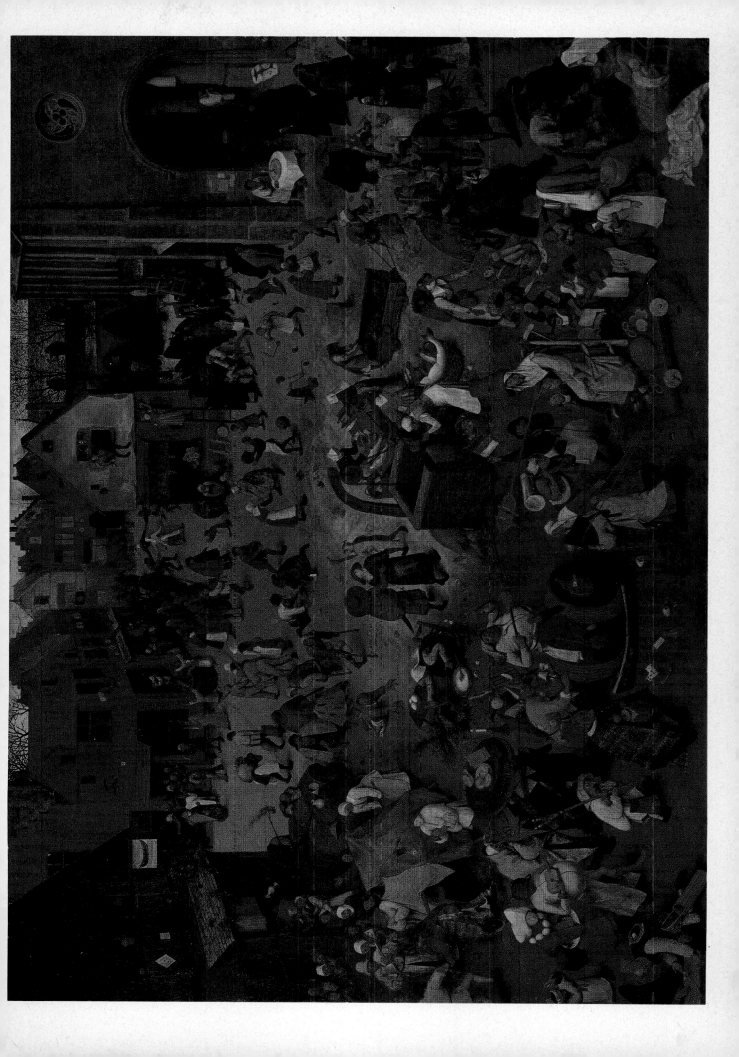

2. The Fight between Carnival and Lent

Detail

Carnival's troop of revellers consists of noisy musicians and curious figures ready for a ramshackle picnic of waffles and bread. They are as peculiar and grotesque as the members of Lent's cortège are proper and orderly.

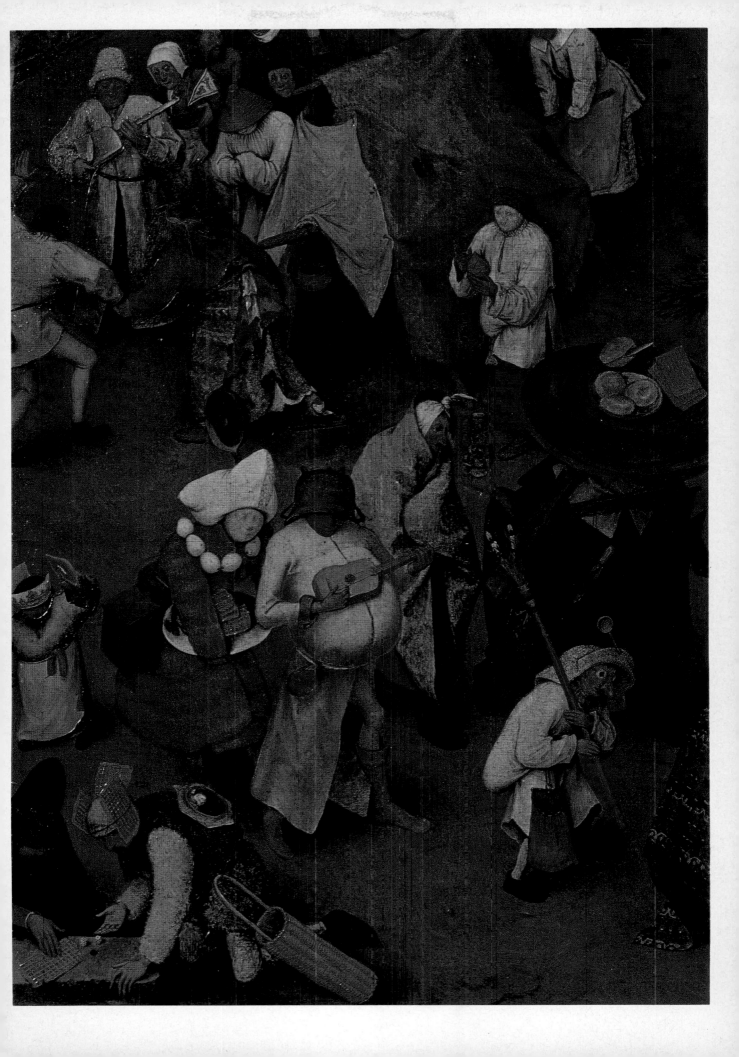

3. *The Netherlandish Proverbs*

Signed and dated 1559. 46 × 64⅛in (117 × 163cm)

In *The Netherlandish Proverbs*, Bruegel displayed his early
mastery of Flemish folklore. He set this encyclopaedia of
proverbs in a village, hard by an estuary. Each motif
depicts a proverb and over a hundred have been identified.
In the centre, a man fills a hole after the calf has drowned
– that is, gives advice when it is too late; nearby a woman
dresses her husband in a blue cloak – that is, cuckolds
him; a man shears a pig and another a sheep – that is, one
has all the profit, the other has nothing. Thus this busy
village landscape is an artistic puzzle, a crossword of
contemporary maxims.

Berlin-Dahlem, Staatliche Museen

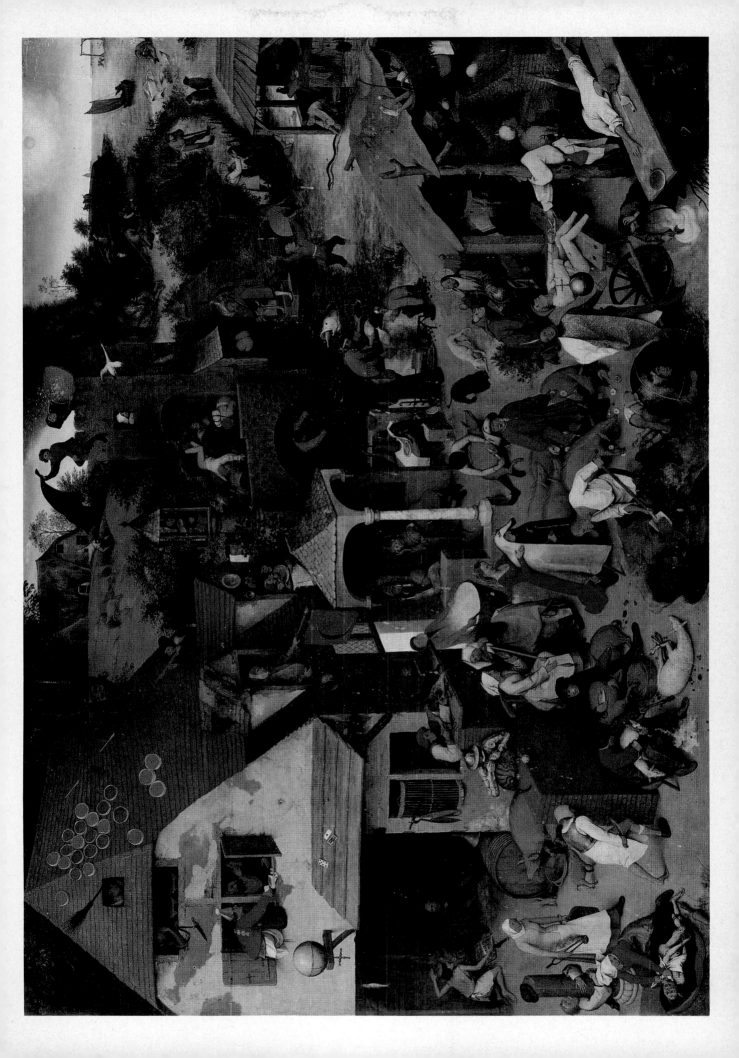

4. *The Netherlandish Proverbs*

Detail

At least seven proverbs are shown here; reading from the top left they are: he trails his cloak in the wind; he throws feathers to the wind; he rubs his behind on a prison door; he falls from a bull onto a donkey; he plays in the pillory; to shave a madman without soap; and, he fishes behind the net.

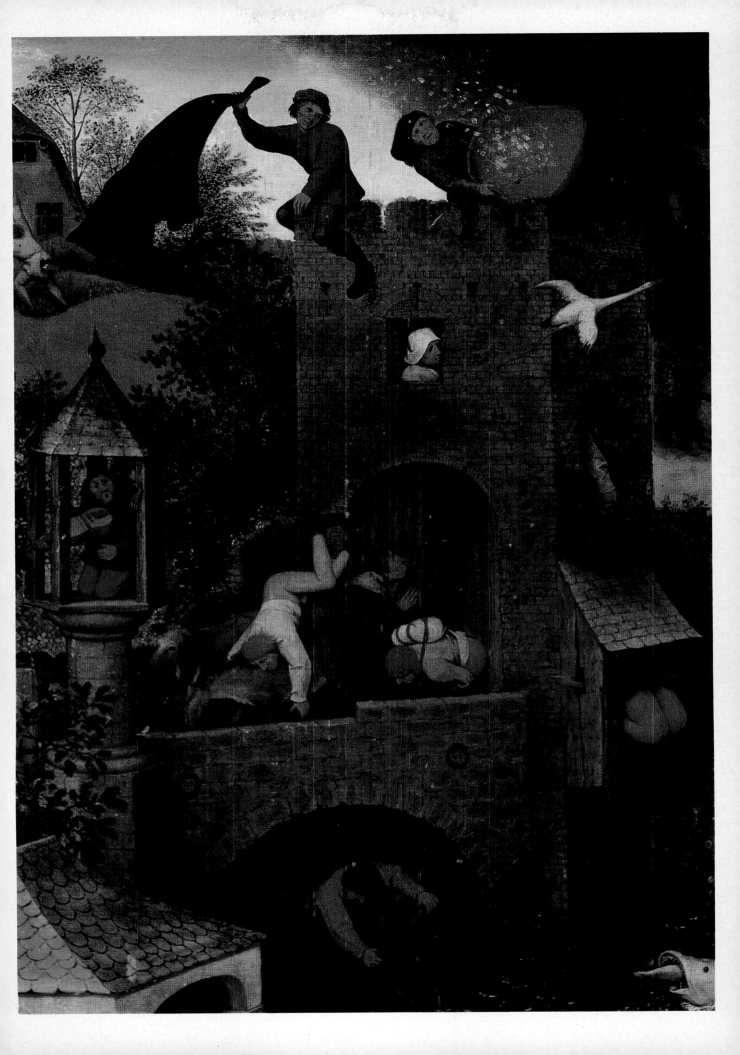

5. *Children's Games*

Signed and dated 1560. $46\frac{1}{2} \times 68\frac{3}{8}$in (118 × 161cm)

Following on the *Netherlandish Proverbs*, Bruegel turned to *Children's Games*, and chose an urban setting, perhaps outside a school. The road stretches far into the picture; in the distance is a church spire, perhaps that of Antwerp cathedral. About eighty different games are depicted with wit and vivacity, the result of many hours of study and observation. It has been suggested that this is the first of an unfinished series representing the Four Ages of Man.

Vienna, Kunsthistorisches Museum

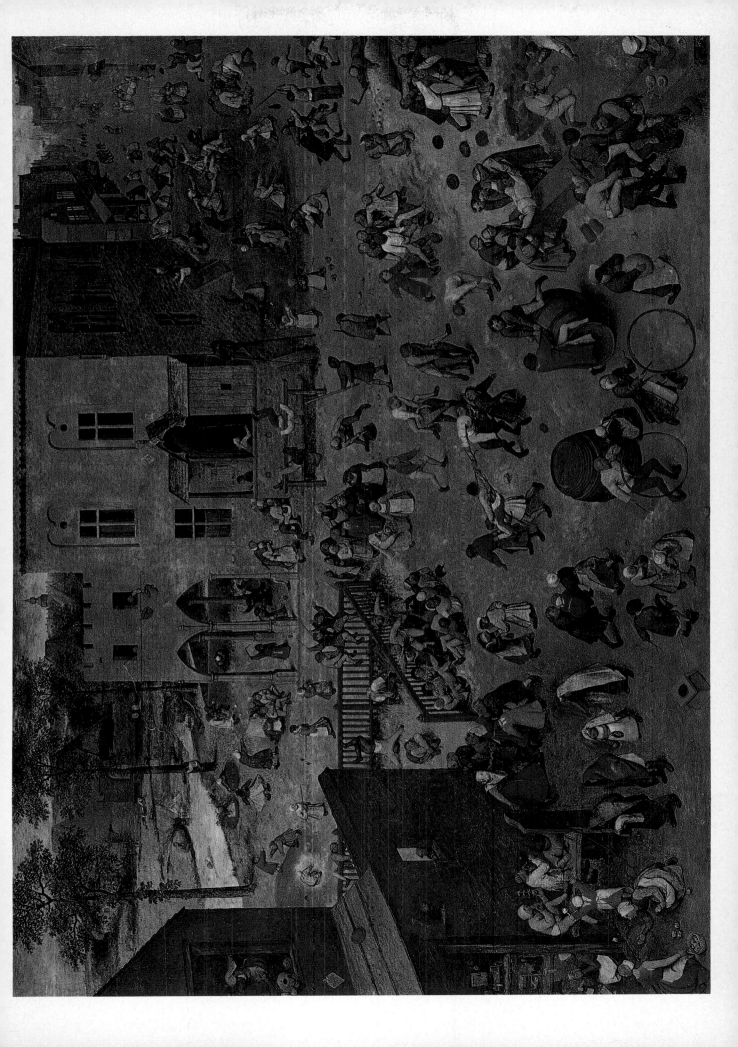

6. *Children's Games*

Detail

A charming detail showing at least nine different
children's pastimes and games by a canal, in which
children are swimming. This landscape vignette with farm
buildings shows that in spite of possible allusions to
Antwerp's architecture, the view was imaginary, as at
that time Antwerp was a walled city.

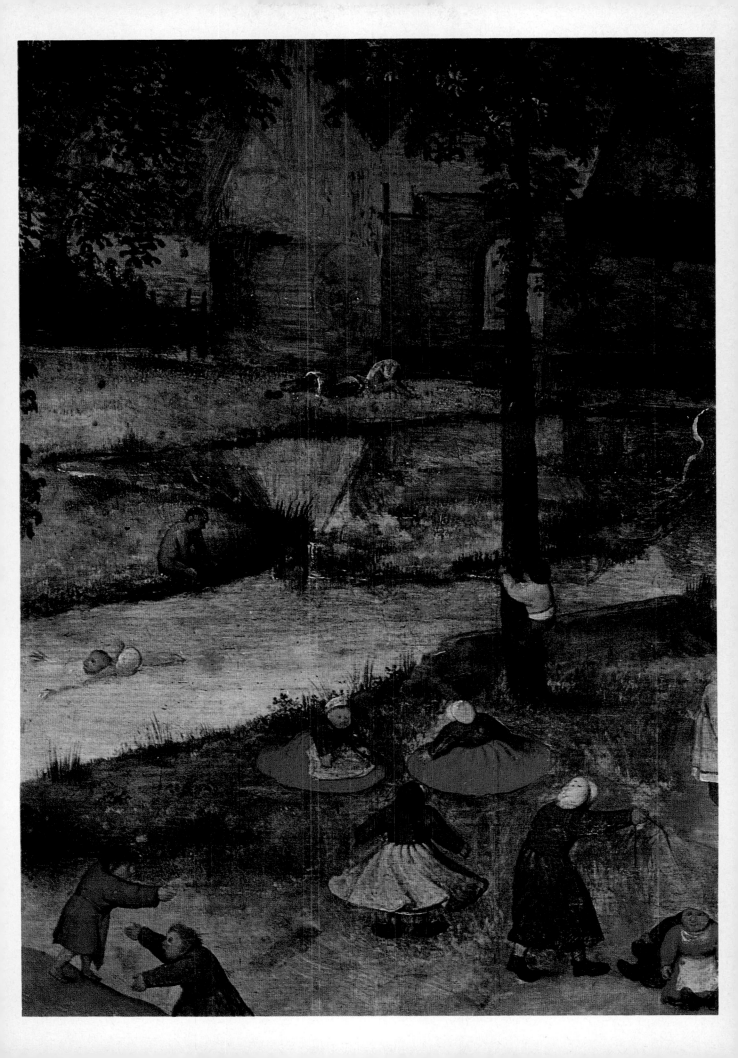

7. *A View of Naples*

$15\frac{5}{8} \times 27\frac{3}{8}$in (39·8 × 69·5cm)

This is the only extant painting of an identifiable locality by Bruegel, who visited Naples in 1552, and probably painted from memory some ten years later using drawings done on the spot. He was engaged at the same time in making a series of engraver's drawings of ships; but we should perhaps assume an admirer from Naples commissioning this work, in which all the prominent buildings of the city are depicted, although the shape of the jetty has been altered. A naval skirmish takes place in the strong offshore breeze; perhaps here was intended a reference to the defence of the city against the Turks, whose sacking of Reggio Bruegel had witnessed not long before he reached Naples.

Rome, Galleria Doria

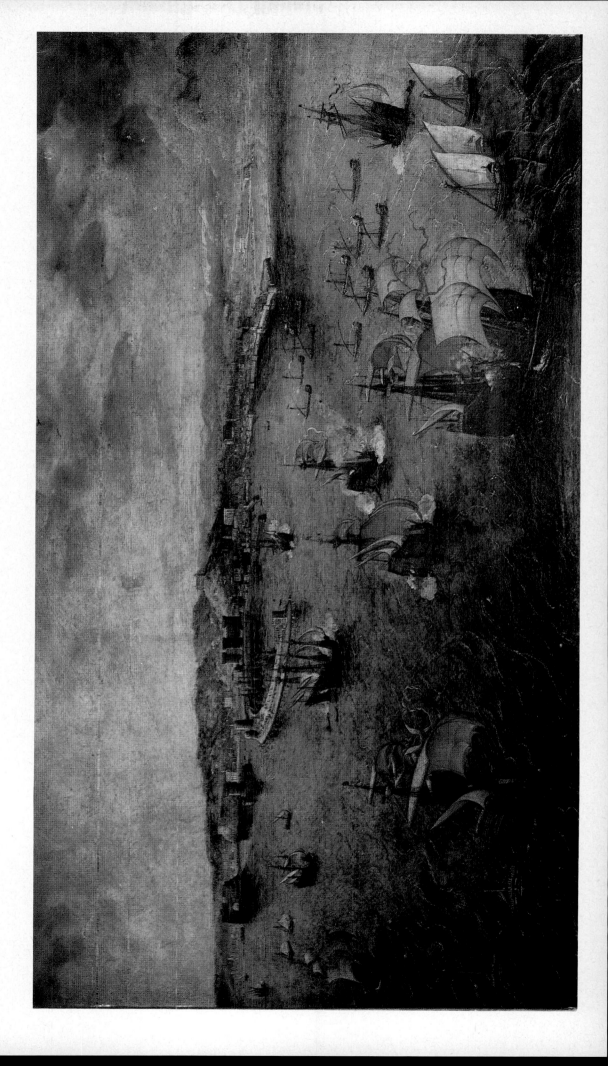

8. *The Suicide of Saul*

Signed, inscribed and dated 1562. $13\frac{1}{4} \times 21\frac{5}{8}$in ($33\cdot5 \times 55cm$)

Bruegel draws on his memories of the Alps and on his
youthful admiration of the imaginary panorama by
Patenier – Antwerp's first landscape specialist – to conjure
up Mount Gilboa, the setting of the Philistines' defeat of
the Israelites and of the suicide of Saul their king. He both
follows and embroiders the Biblical account, to which he
refers in an inscription accompanying his signature. The
archers that turned a flight into a rout are shown on the
promontory dominating the defile where the Israelites
were to be ambushed. The ambush is depicted in an
Altdorfian idiom of swaying lances; Saul has abandoned
his troops and sought a lonely rock. As his army seeks to
scramble away to safety up the mountain pass, some
soldiers follow to find him dying on his sword and his
armour-bearer falling 'likewise upon his sword' to die with
him. Beyond in the valley are Israelites, already aware of
Saul's defeat, forsaking their cities and fleeing. Saul had
been undone by the sin of pride; Bruegel describes that
sin's consequences in contemporary terms of an army
routed, as its crowned leader slowly dies, head turned in
agony towards it.

Vienna, Kunsthistorisches Museum

9. *The Fall of the Rebel Angels*

Signed and dated 1562. 46 × 63¾in (117 × 162cm)

With extraordinary virtuosity, Bruegel makes the spectator almost a participant in this triumph of the forces of good over evil. The rebel angels have already been transformed into fantastic, Bosch-like creatures, the miscegenated emblems of sin, as they tumble from heaven to populate hell. Sin has made the rebels monstrous; pride has transformed Lucifer into a many-headed reptile, whose tail twists heavenwards. It seems that he will fall right onto the spectator; by such an illusion Bruegel asks us to examine our own consciences. In no other work does he reveal his admiration of Bosch so clearly.

Brussels, Musées Royaux des Beaux-Arts

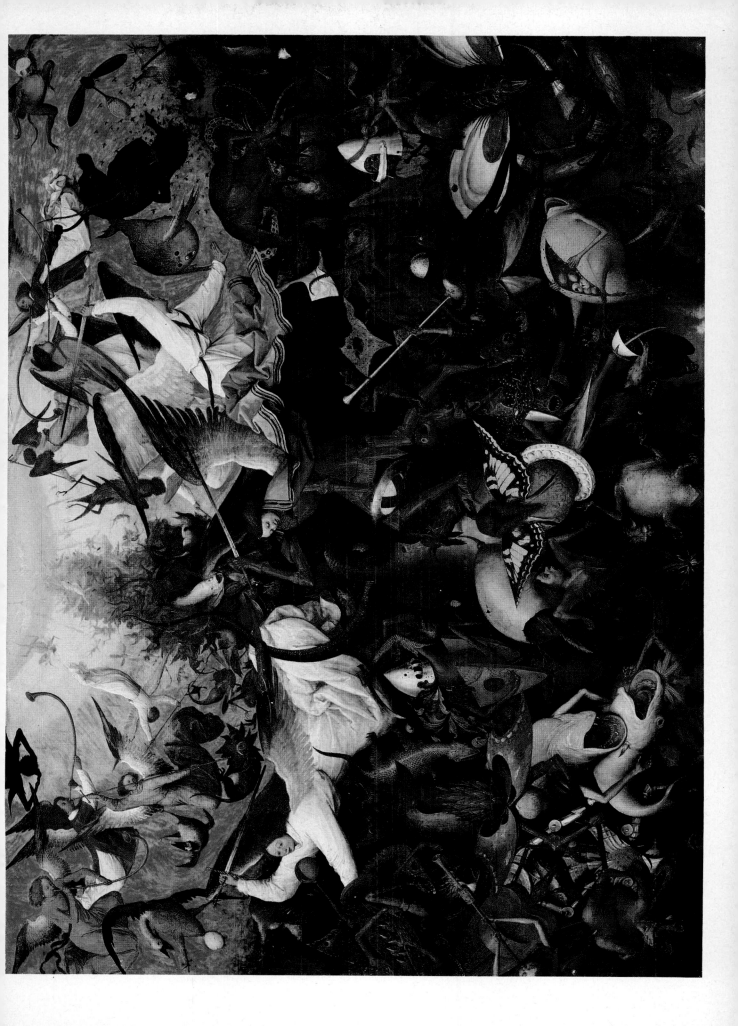

10. *Two Monkeys*

Signed and dated 1562. 7⅞ × 9in (20 × 23cm)

This seems a simple memento, but in fact the idea of depicting two monkeys in their casement home is novel and extraordinary by any account. No explanation has been given that throws light on this moving, gloomy work. The monkeys are prisoners; their casement is thick and made of stone; beyond is the Scheldt and Antwerp. Conjecture suggests that this may refer to prison life and to imprisonment. Bruegel had depicted prisoners in prints; this picture may be no more and no less than a view from a prison cell.

Berlin-Dahlem, Staatliche Museen

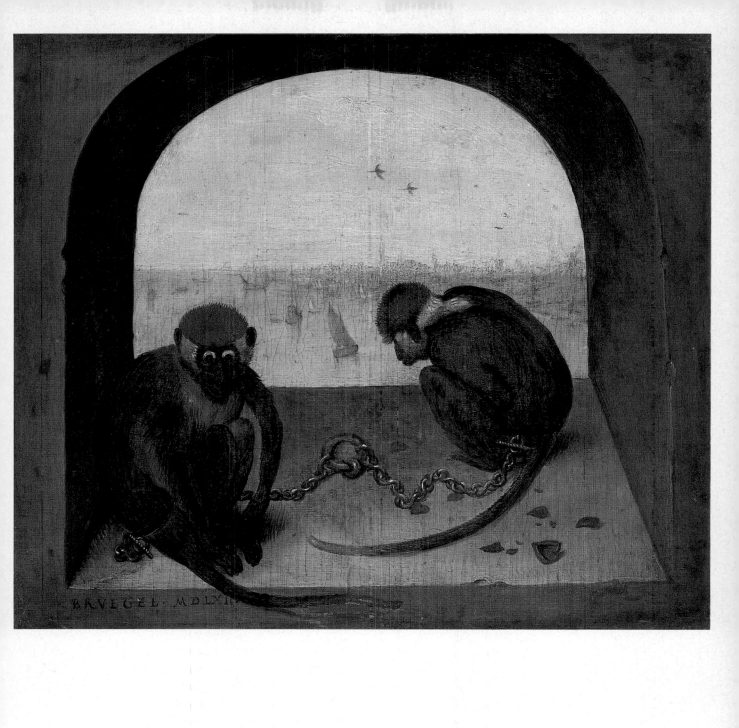

11. *Dulle Griet (Mad Meg)*

Indistinctly signed and dated 1562 (?). $45\frac{1}{4} \times 63\frac{3}{8}$in (115 × 161 cm)

The sin of covetousness is probably Bruegel's subject: Dulle Griet – the crazy hag – personifies it as, breast-plated and sword in hand, she is prepared even to invade hell to satisfy her desire. She will fight to do so like the women at the portals of this Boschian hell. She storms past them seeking new territory, carrying the loot she has already won.

Antwerp, Musée Mayer van den Bergh

12. *Dulle Griet*

Detail

This anthropomorphic fantasy shows Bruegel's love of
Boschian visual acrostics. Its precise meaning is not clear.
A scrawny old man balances a ship of fools on his
shoulders, shovelling excreta from a broken egg from the
top of the inn where he sits. Beneath are the covetous
about to enter hell.

13. *The Triumph of Death*

46 × 63¾in (117 × 162cm)

Probably painted about 1562, the *Triumph of Death* may
owe something to Bruegel's wanderings in Sicily as a
young man: its idiom alone accords well with the Hispano-
Latin obsession with death and it is appropriate that it
should have formed part of the Spanish royal collection.
Bruegel in fact combines Italian and German attitudes to
death and interprets them through the eyes of Bosch to
create this morbid panegyric. Death's empire is revealed to
a group of revellers; the women are quickly hustled away,
but to the soldiers who draw their swords the inevitable
stretches out before them in a gruesome landscape.
Neither king nor prelate can escape Death's embrace, as
the great coffin is opened to receive all in Death's
triumphant grasp.

Madrid, Prado

14. *The Triumph of Death*

Detail

A gruesome detail from this funereal painting showing
Death with his scythe on a ravenous charger. Death spares
no one and the army of death moves forward to inexorable
victory, ignoring all pleas for mercy.

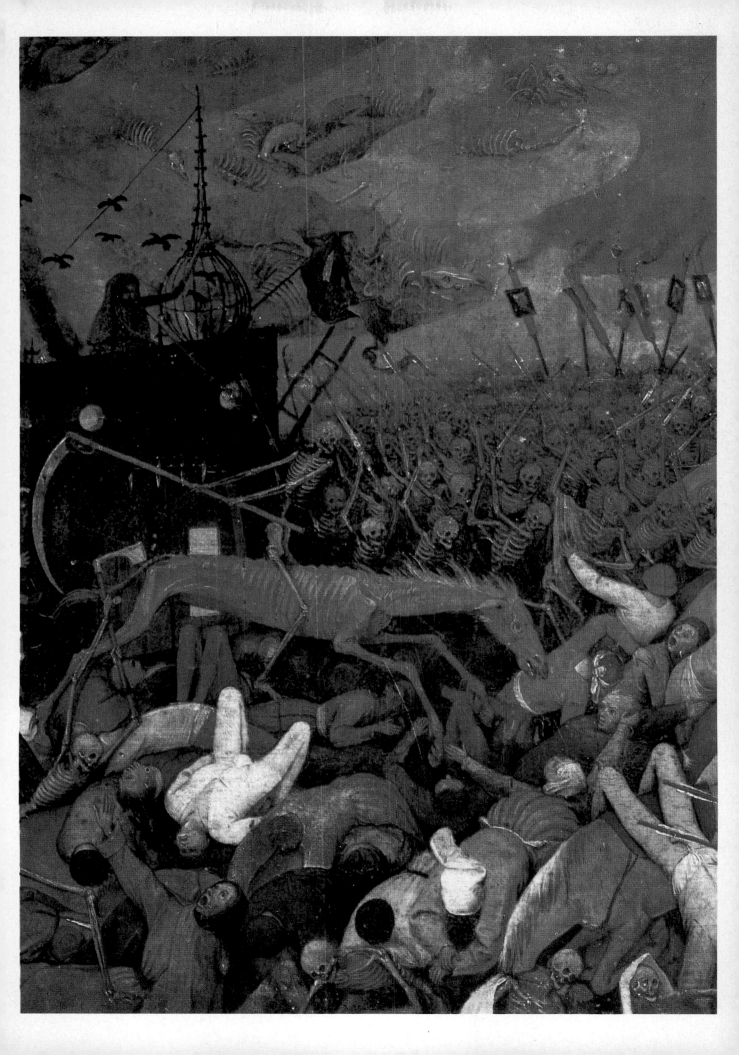

15. *The Death of the Virgin*

Grisaille. Signed. 14½ × 22in (36 × 54·5cm)

The Death of the Virgin, probably painted towards the end of Bruegel's years in Antwerp or very soon after he arrived in Brussels, is the only work for which there exists near-contemporary criticism. Needless to say it was laudatory. Painted for Bruegel's Antwerp friend, the cartographer Abraham Ortels, it was engraved at his behest in 1574; the print gave deep pleasure to another member of the artist's old circle in Antwerp, Dierick Coornhert, who wrote to Ortels: 'Never, methinks, did I see . . . finer engraving than this sorrowful chamber. . . . I actually heard . . . the melancholy words, the sobbing, the weeping and the sounds of woe . . .'. Bruegel depicts the vision of the Virgin's death as it appeared to St John the Evangelist asleep by a Flemish fireside at night.

Banbury, England, Upton House (National Trust)

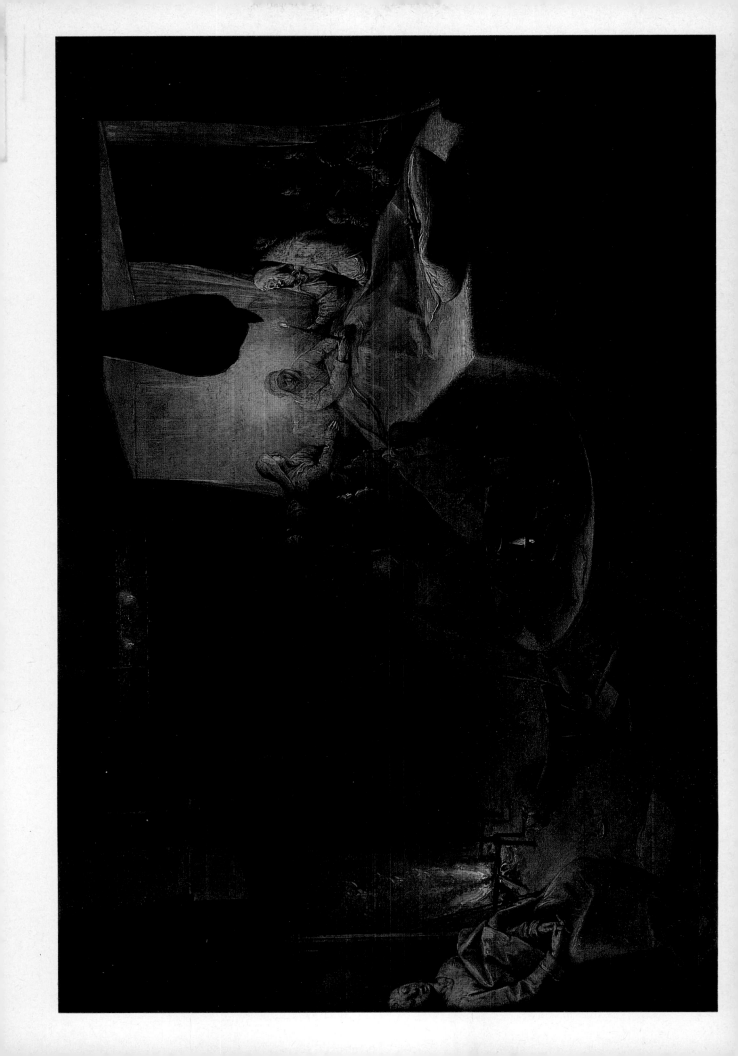

16. *The Tower of Babel*

Signed and dated 1563. $44\frac{7}{8} \times 61$ in (114 × 155cm)

Nimrod, the 'mighty hunter before the Lord' and the first
king of Babel, is shown visiting stonemasons at work on
the tower whose top was to 'reach unto heaven'. Nimrod,
like Saul, was guilty of the sin of pride; and Bruegel uses
the Biblical story – turning Babel into a medieval seaport –
to comment on man's vanity. The tower already dwarfs
the town, and work continues apace, the builders using
the types of cranes and lifts that Bruegel must have
observed on the great building sites in Antwerp. He is
known to have painted this subject on two other
occasions, in Rome, on ivory – a work which is recorded
in the estate of Clovio – and in the picture at Rotterdam, in
which the tower slants even higher, countryside replaces
the city, and while work continues on the mad enterprise,
Nimrod's visit is not included.

Vienna, Kunsthistorisches Museum

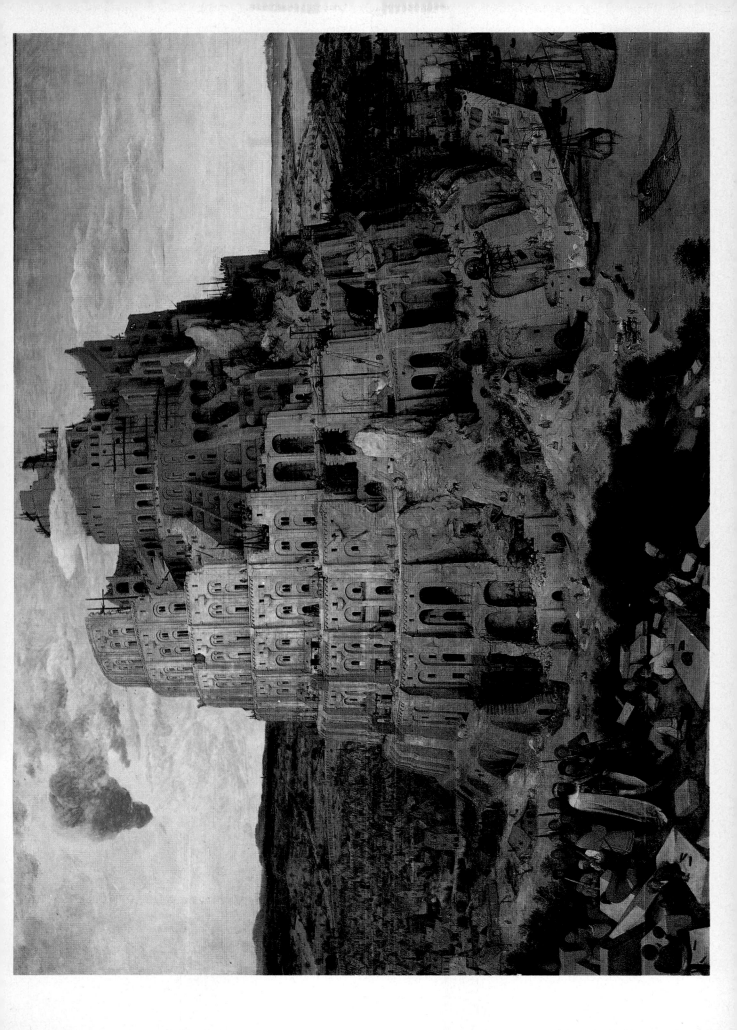

17. *The Procession to Calvary*

Signed and dated 1564. 48¾ × 66⅞in (124 × 170cm)

Probably painted for Niclaes Jonghelinck, this is Bruegel's largest painting, and while it can be compared and perhaps was to some extent inspired by the work of Aertsen, Bruegel's treatment of the *Procession to Calvary* seems entirely original. St John and the three Maries mourn in the foreground as if the execution has already taken place; they are dressed in 'historical' costume and seem not to be part of the scene that is taking place behind them. That is seen in contemporary terms – executions were normally conducted outside the city walls; the two thieves in a tumbril are accompanied by monks and observed by the crowd with looks of frightened curiosity. No one comforts Christ staggering beneath the Cross; but soldiers press Simon of Cyrene to perform the task. The crowd makes a passage for Simon, who is terrified at being forced to declare himself and is held back by his desperate, hypocritical wife. This concept of a pusillanimous Simon was new, and is a comment on the times when religious differences and repression faced many with the choice of compromise or death.

Vienna, Kunsthistorisches Museum

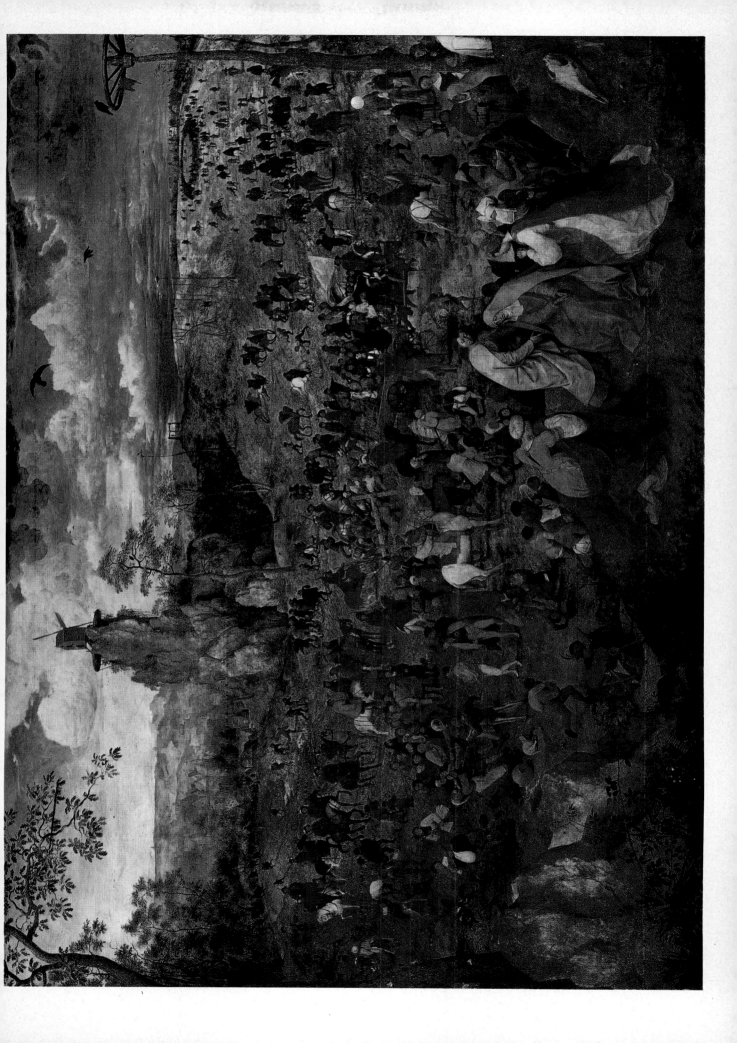

18. *The Adoration of the Magi*

Signed and dated 1564. 43¾ × 32¾in (111 × 83·5cm)

Bruegel's only fully worked-up oil painting of upright format, and his first to treat figures on a scale approaching the life-size, this *Adoration of the Magi* is no scene of joy or rapture. The Virgin and Child are surrounded by ugliness; the Child cringes from the kneeling Magus, and even St Joseph seems bloated and self-satisfied. He listens to a confidential whisper from a bystander, a curious and disturbing motif introduced by Bruegel.

London, National Gallery

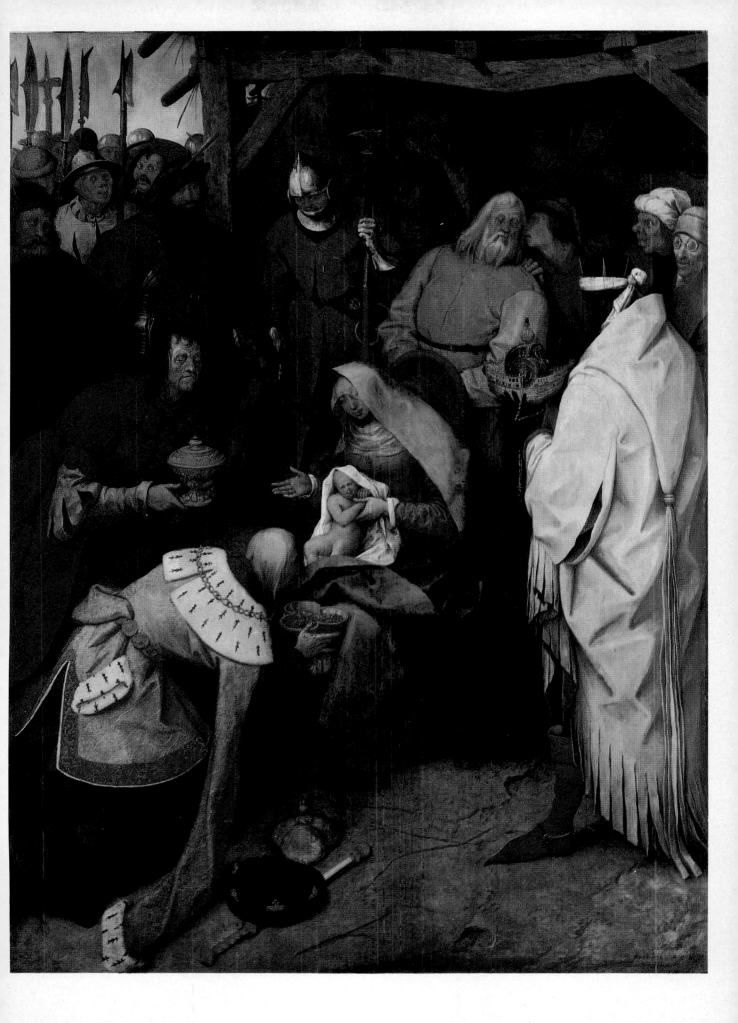

19. *The Month of January (?) (Hunters in the Snow)*

Signed and dated 1565. 46 × 63¾in (117 × 162cm)

Bruegel's first winter landscape, and one of his greatest masterpieces, this was probably intended to represent January in a series to depict the twelve months of the year. It is thought that the series was commissioned by Niclaes Jonghelinck and recorded in his possession in 1566 (*see note to plate 24*). Bruegel presents a panorama of hills and a river valley dominated by far-off mountains all under snow. The frozen ponds and river extend as far as the town with its church spire in the distance. The air is sharp and clear; people skate on the ponds below as huntsmen return from the chase.

Vienna, Kunsthistorisches Museum

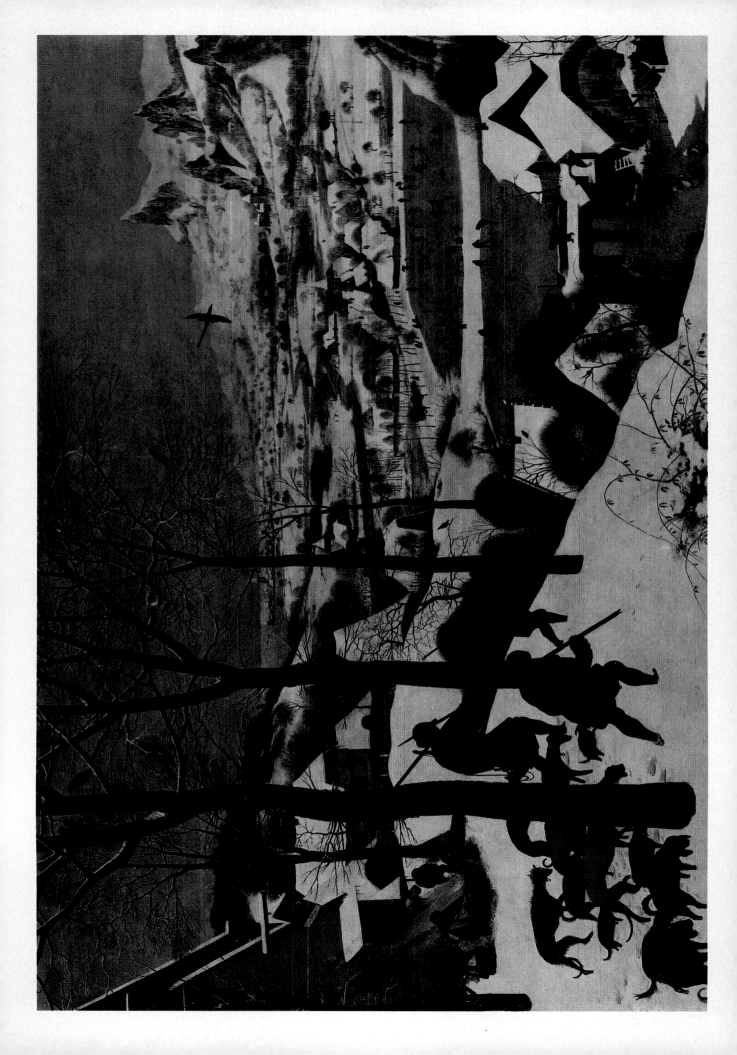

20. *The Month of February (?) (The Gloomy Day)*

Signed and dated 1565. 46½ × 64⅛in (118 × 163cm)

Part of the same series as plate 19, this view of a hamlet by an estuary on a cold, stormy day was probably intended to represent February. Peasants gather wood and make merry before Lent, while most prefer to remain indoors. Beyond, ships founder in a gale, in this the gloomiest of months.

Vienna, Kunsthistorisches Museum

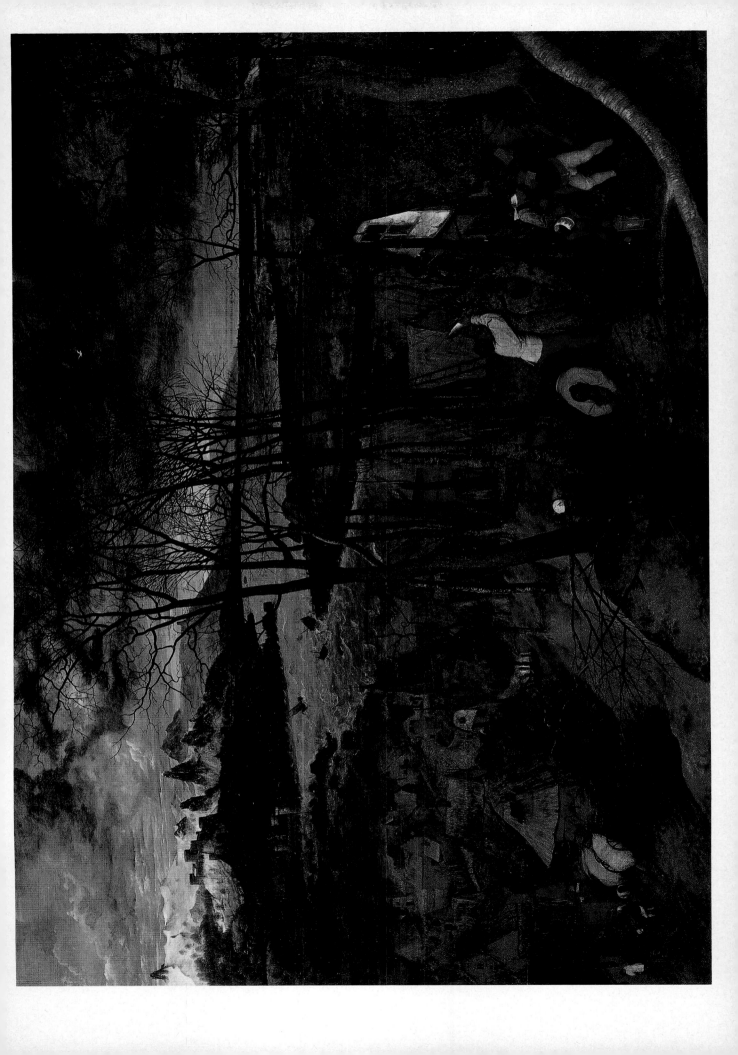

21. *The Month of July (?) (Haymaking)*

46 × 63⅜in (117 × 161cm)

For July, in the same series as plate 19, Bruegel presents a scene of busy activity in the country: the crop of hay is garnered and fruit and vegetables are picked and carried away for storage or sale. The three peasants striding along the path to continue with the haymaking embody the air of fruitful labour that Bruegel creates in this fecund landscape view.

Prague, National Gallery

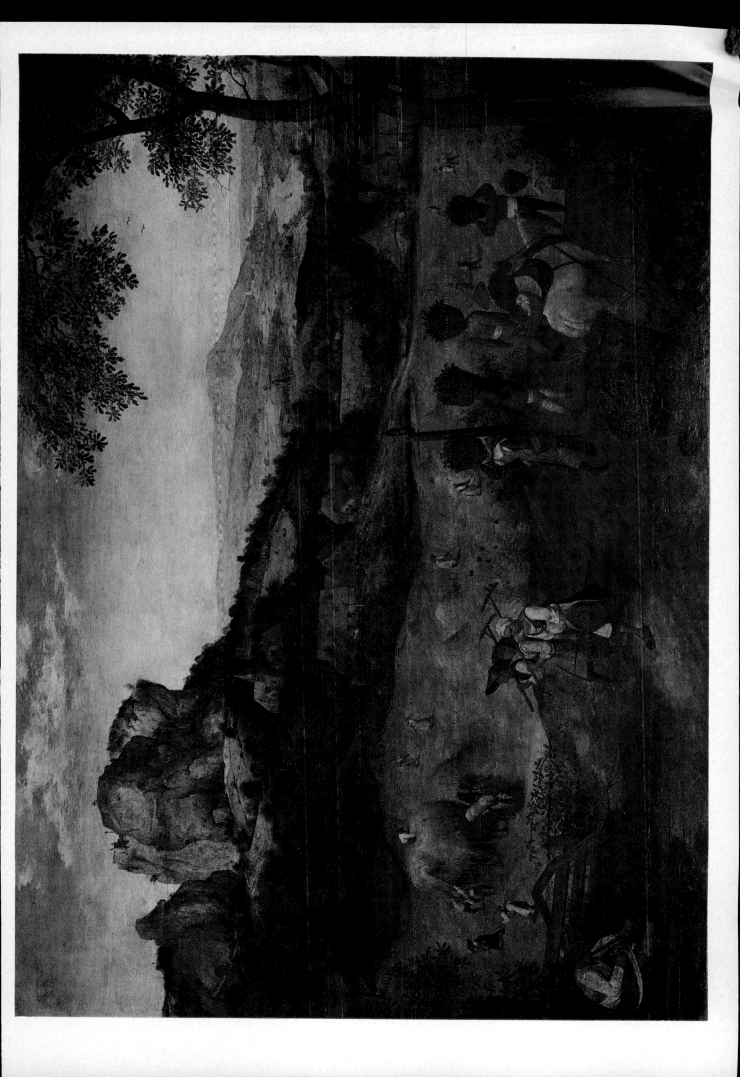

22. *The Month of July (?)*

Detail

The three heroines of July (?) are shown striding along
with their rakes for more haymaking. This picture was
known to Rubens, who greatly admired Bruegel. His
Return from the Fields (Palazzo Pitti), painted some seventy
years later, owes much to Bruegel's July (?), and contains
a paraphrase of this group.

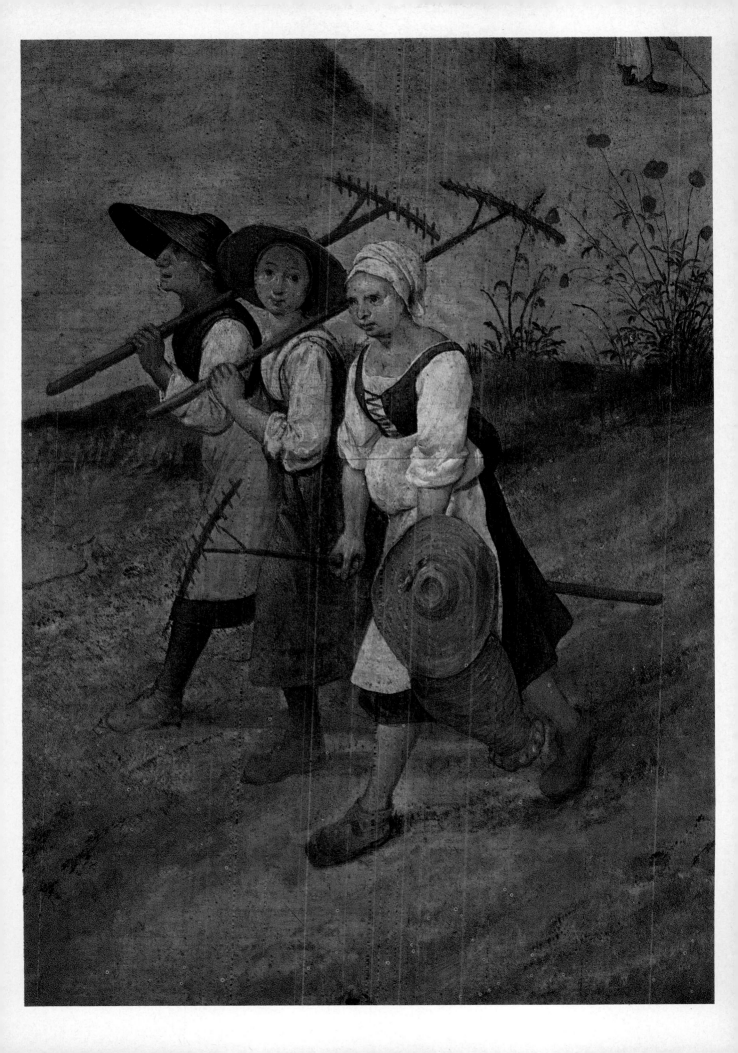

23. *The Month of August (?)*
(The Corn Harvest)

Signed and indistinctly dated 1565. 46½ × 63¼in
(118 × 160·7cm)

High summer – August – and the corn harvest: after
January, this is Bruegel's most memorable and vivid
evocation of a month in this extraordinary series that is
revolutionary on account of both scale and imaginative
detail. Corn yellow is now almost as dominant as the
white of snow had earlier been. The heat makes the
peasants' task as arduous as had the cold. Some choose to
rest and eat in the midday sun under a tree, as others
continue determinedly with the harvest, although rain
indeed seems unlikely in the sense of shimmering heat that
Bruegel has managed to convey.

New York, Metropolitan Museum of Art

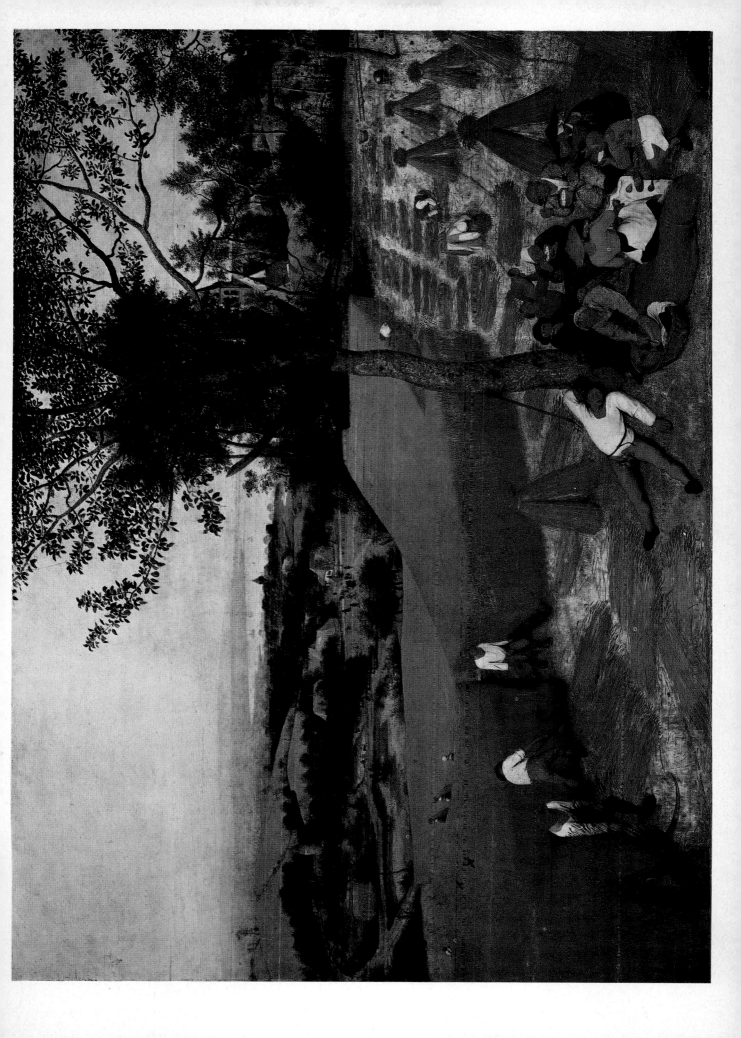

24. *The Month of November (?) (The Return of the Herd)*

Signed and dated 1565. 46 × 62⅝in (117 × 159cm)

For November, the last of the series which is extant, Bruegel chose an extensive Alpine valley and the return of the cattle to winter quarters from the summer pastures. The headman on his horse is well protected, and the trees are already bare. Some peasants work in the vineyards below; but with the cattle safely stabled, the peasants are prepared for the rigours of winter.

These five paintings, it is generally considered, are all that remain of a group of twelve in the possession of Niclaes Jonghelinck in 1566. As all but one is dated the previous year, it can be assumed that the series was painted for him. A later record of six paintings of the months of the year has led some critics to suggest that these paintings each represent two months and that therefore only one of the series is missing. Whether this is correct, and whatever the specific identification of some of the subjects, there can be no doubt that the series, taking up the traditional calendar theme, provided a profoundly realistic evocation of the seasons and life in the countryside that has rarely, if ever, been equalled.

Vienna, Kunsthistorisches Museum

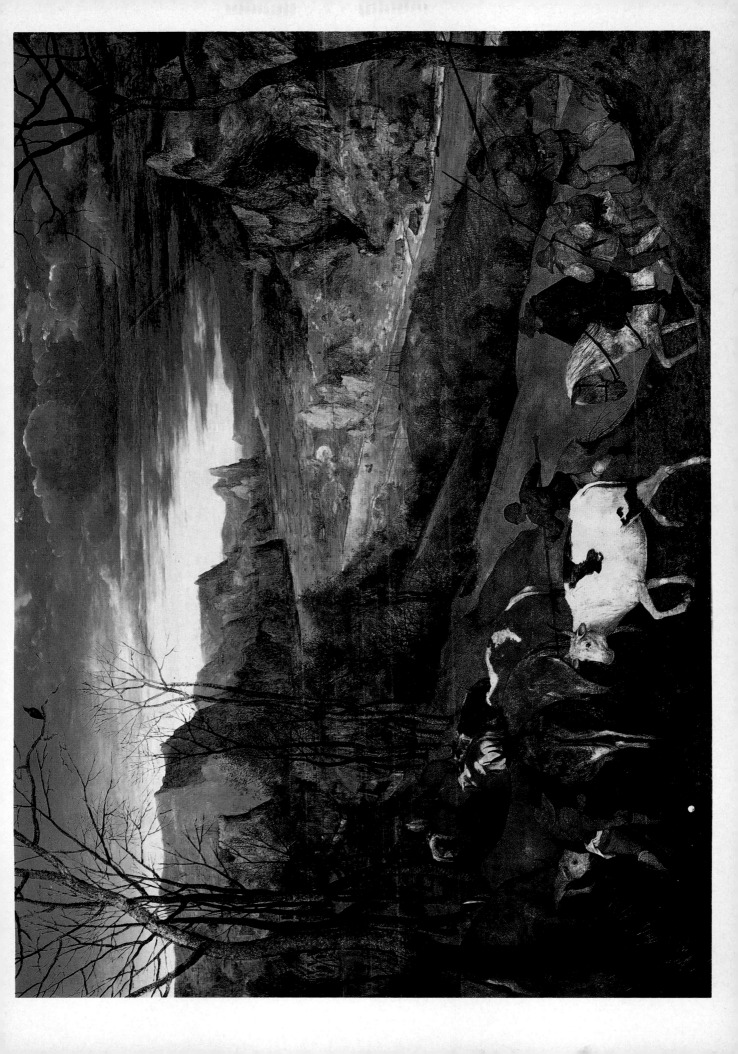

25. *The Numbering at Bethlehem*

Signed and dated 1566. 45⅝ × 64¾in (116 × 164·5cm)

There are few precedents for Bruegel's depiction of Joseph and the pregnant Mary arriving in Bethlehem to pay the tax imposed by Caesar. He sets the scene in a snow-covered Flemish village at sunset. The Imperial tax gatherers have established themselves in an inn and collect money as pigs are slaughtered in preparation for the feasting that is to come. The ruined castle in the distance alludes to King David's castle and allows the identification of the village as Bethlehem; but for that and the presence of the holy couple, this would be a vividly detailed account of village life in winter. Life goes on as the drama of the Nativity is about to unfold.

Brussels, Musées Royaux des Beaux-Arts

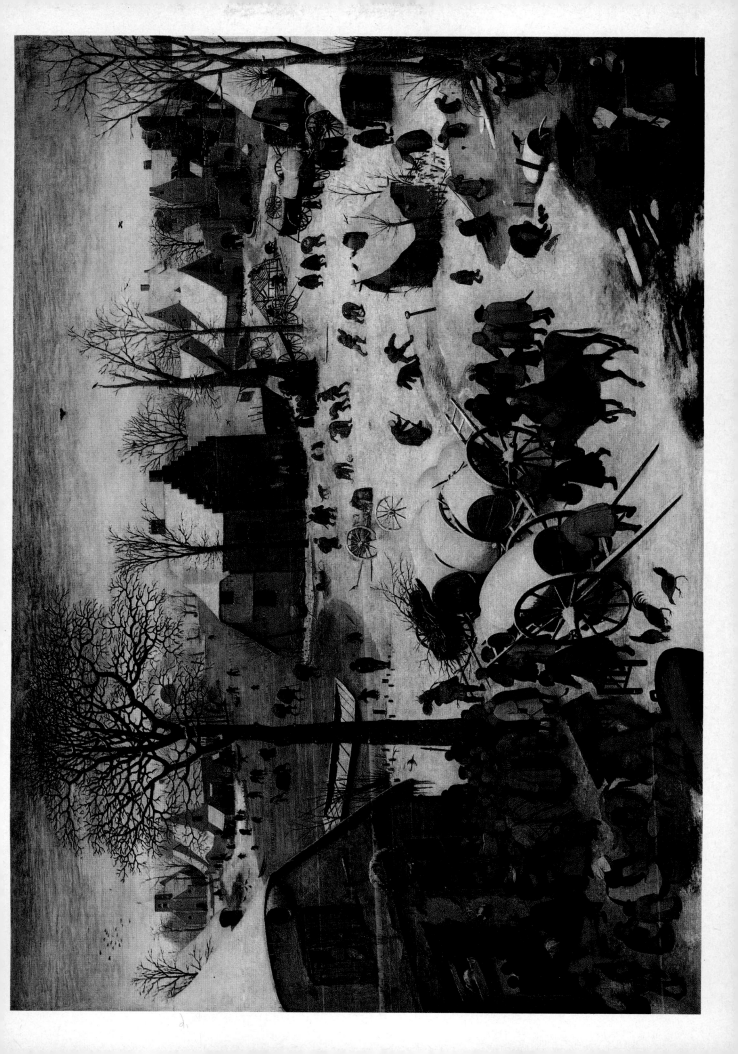

26. *St John the Baptist preaching in the Wilderness*

Signed and dated 1566. 37$\frac{3}{8}$ × 63$\frac{1}{4}$in (95 × 160·5cm)

In 1565, the proscribed Calvinists in the Netherlands took to the countryside to preach; Bruegel's *St John the Baptist preaching in the Wilderness* – a wilderness that is plainly the Flemish countryside – alludes to these outdoor gatherings. Christ miraculously appears amid the audience as St John preaches His coming. All sorts are present; and the subject seems to indicate Bruegel's sympathy with the outlawed Protestants, but for the prominent burgher, who sits ignoring St John and prefers to have his fortune told by a gypsy.

Budapest, Museum of Fine Arts

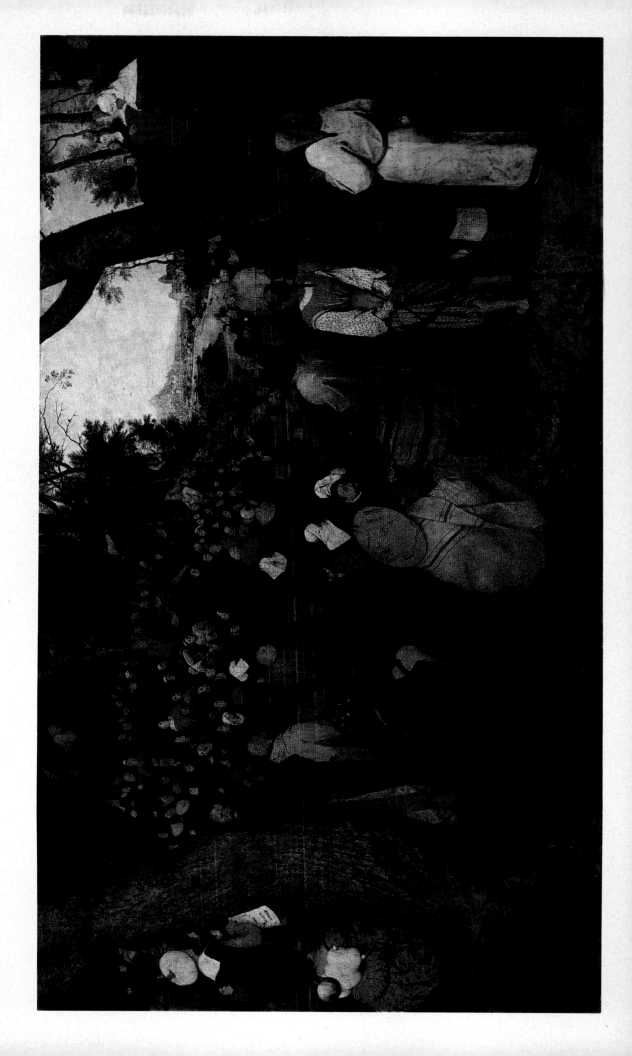

27. *St John the Baptist preaching in the Wilderness*

Detail

The telling of fortunes by the gypsy, who ignores the sermon, is an activity condemned by both Catholic and Protestant alike. Most of the rest of the crowd listens attentively, including the two monks in the top right corner of this detail. Their presence at this outdoor gathering emphasizes that the painting as a whole should not be seen merely as a veiled reference to the activity of the Calvinists.

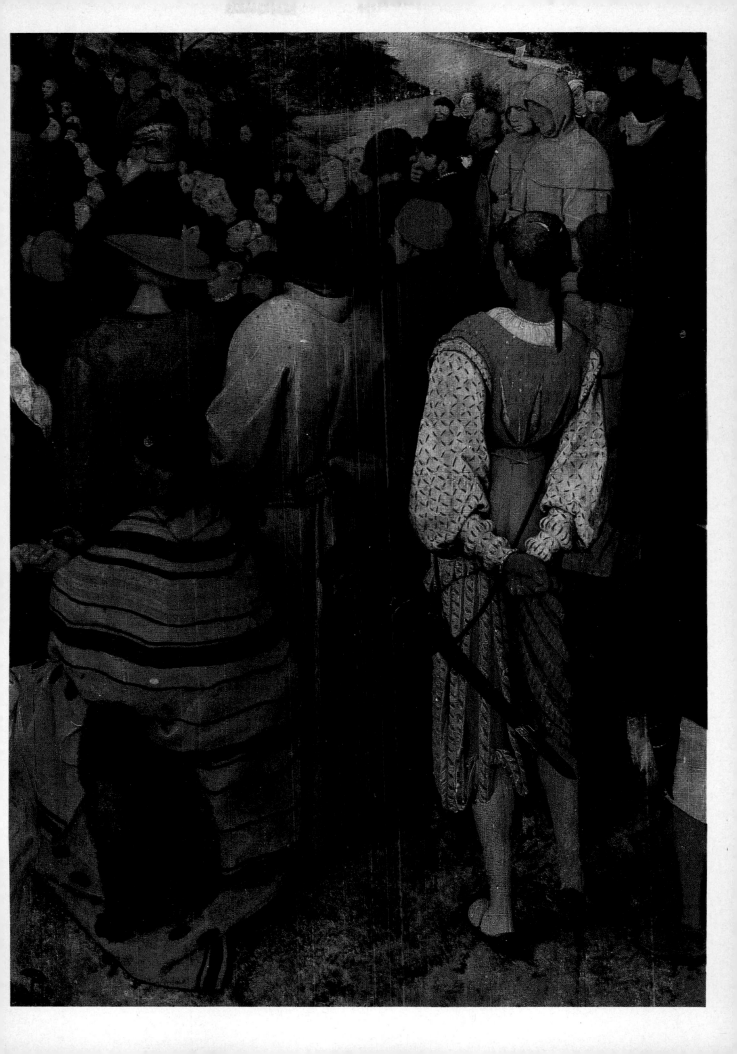

28. *The Massacre of the Innocents*

Inscribed. 45⅝ × 63in (116 × 160cm)

One of two versions of the subject to have been executed
in Bruegel's studio during his lifetime, the Vienna picture is
now thought to have been largely the work of an assistant
in about 1566–7, following the picture at Hampton Court.
It is winter and two separate detachments of troops have
converged on the main street of a village. They now
search out and murder the children. Herod's act of anger
and fear is told by Bruegel in contemporary terms with an
unerring eye for frightening and harrowing detail. It has
been suggested that the composition was a scarcely veiled
protest at the presence of Spanish troops in the
Netherlands and the 'Spanish terror' of 1567; more likely
Bruegel chose to bring home the Bible story by drawing on
his own knowledge and imagining the misery inflicted by
punitive expeditions, experienced in every age.

Vienna, Kunsthistorisches Museum

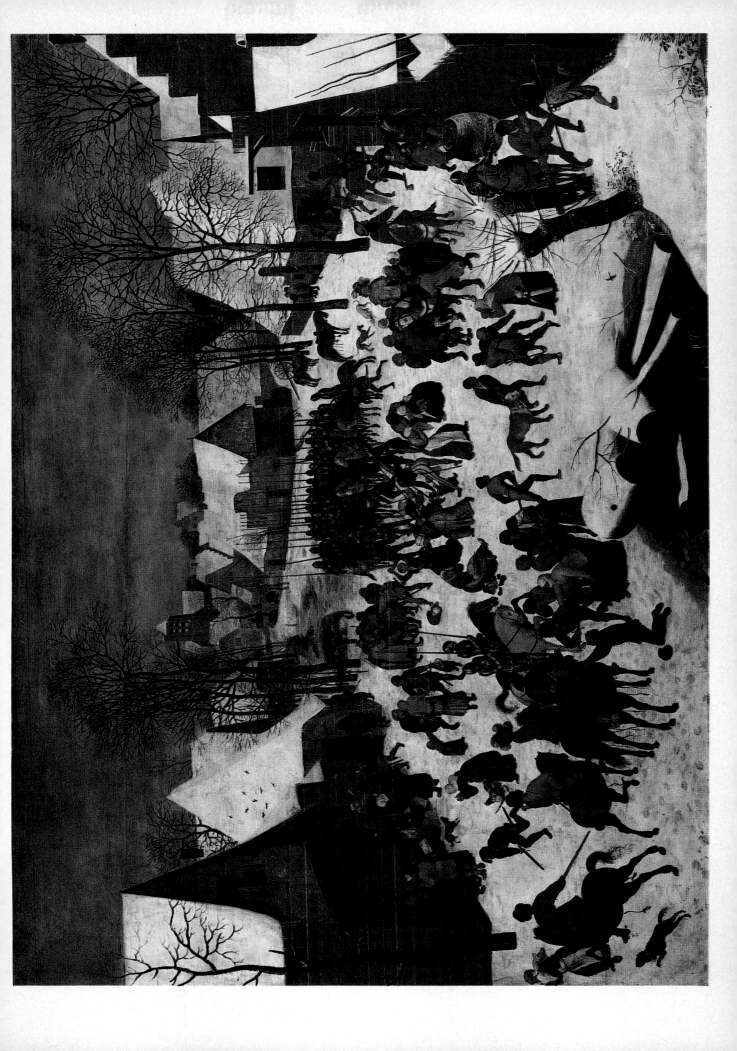

29. The Conversion of St Paul

Signed and dated 1567. $42\frac{1}{2} \times 61\frac{3}{8}$in ($108 \times 156$cm)

Saul's road to Damascus, like the setting for the suicide of his Old Testament namesake, was seen by Bruegel as an Alpine pass. Saul with his troops is on a mission to persecute more Christians when 'suddenly there shined around him a light from heaven: and he fell to the earth . . .' to be blinded and then converted. His escort stands and waits, watching the extraordinary event that Bruegel, with a true dramatist's skill, places in the middle distance as he had earlier placed Christ in *The Road to Calvary*. Now, however, the spectator feels part of the action, quite close to those soldiers that Bruegel's contemporaries could have recognized out on patrols.

Vienna, Kunsthistorisches Museum

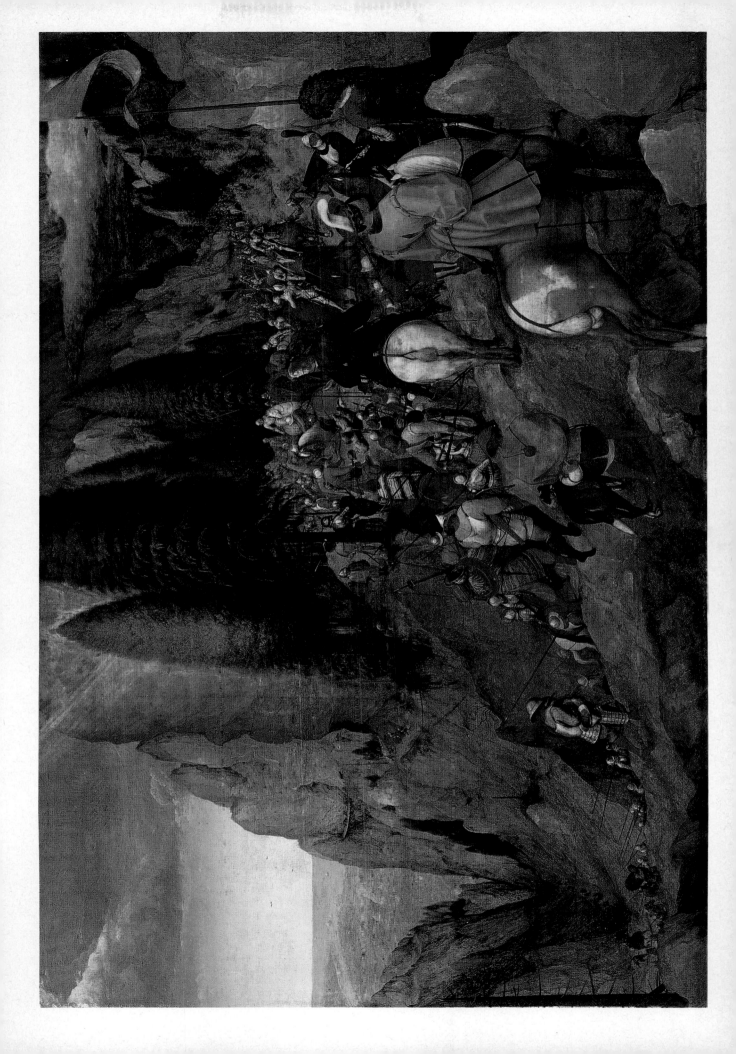

30. *The Conversion of St Paul*

Detail

Soldiers and attendants wait on a mountain pass as Saul falls, miraculously blinded. This detail shows not only Bruegel's underdrawing in pencil here and there – a typical Netherlandish technique – but also his clearly written signature in capital letters, that appears on the majority of his paintings.

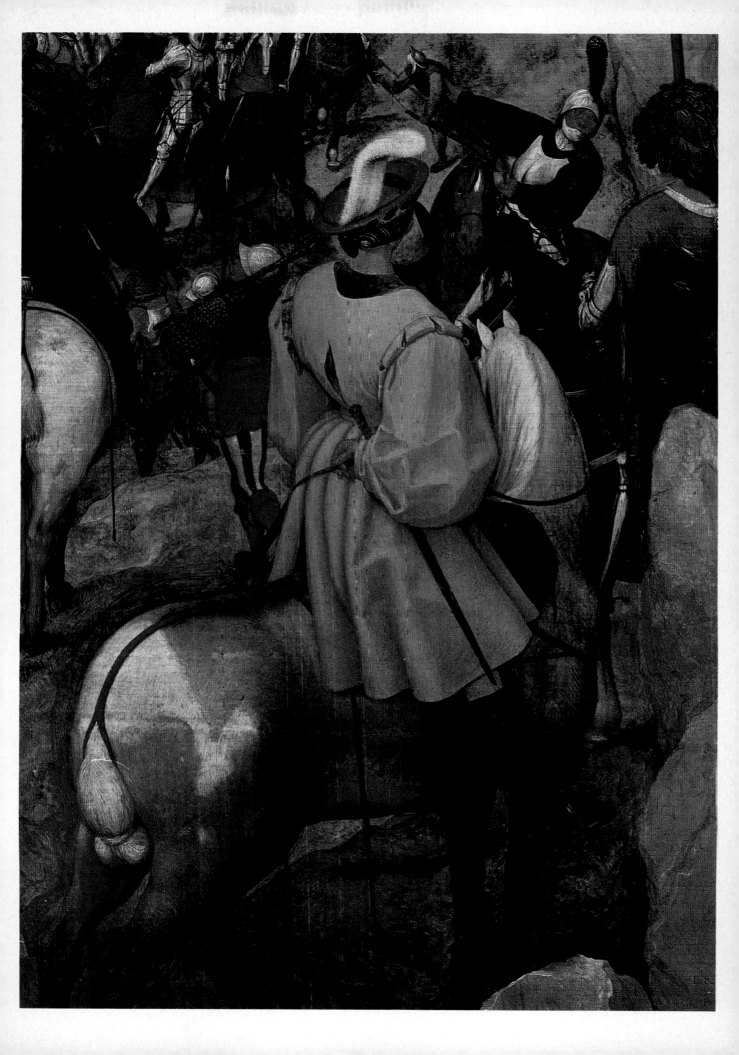

31. *The Land of Cockaigne*

Signed and dated 1567. 20½ × 30¾in (52 × 78cm)

Here a scholar, a peasant and a soldier lie daydreaming or asleep beneath a table in the open air, overcome by gluttony and laziness. The moral is obvious. Bruegel's mastery of the human form is evident in much of his work, but nowhere more than in the foreshortened rendering of the sleeping soldier.

Munich, Alte Pinakothek

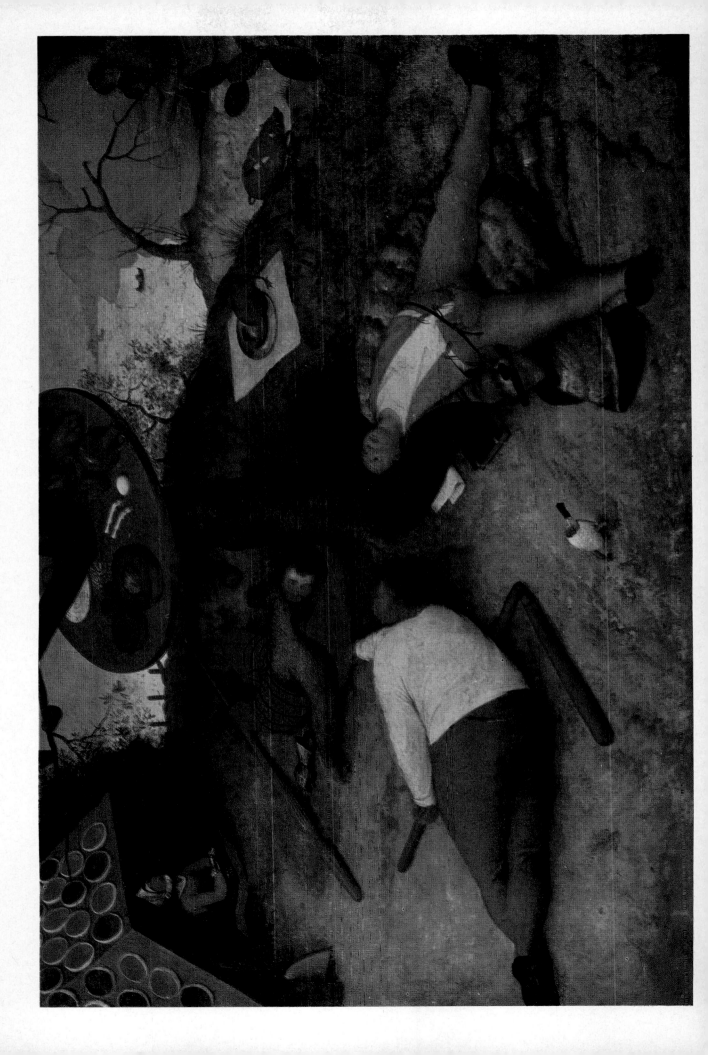

32. *The Fall of Icarus*

Transferred from panel to canvas. 29 × 44⅛in (73·5 × 112cm)

The fall of Icarus is the only mythological subject known to have been treated by Bruegel. Icarus disobeyed his father Daedalus and flew so high in their escape from Crete that his wax wings melted and he plunged to his death. The victim of vanity and foolhardiness, he tumbles headlong into a calm estuary; neither shepherd nor ploughman on the verdant promontory notice, and the galleon sails on out to sea. Usually dated soon after his return from Italy, this picture, of which there exists another version, should rather be dated to Bruegel's last years in Brussels.

Brussels, Musées Royaux des Beaux-Arts

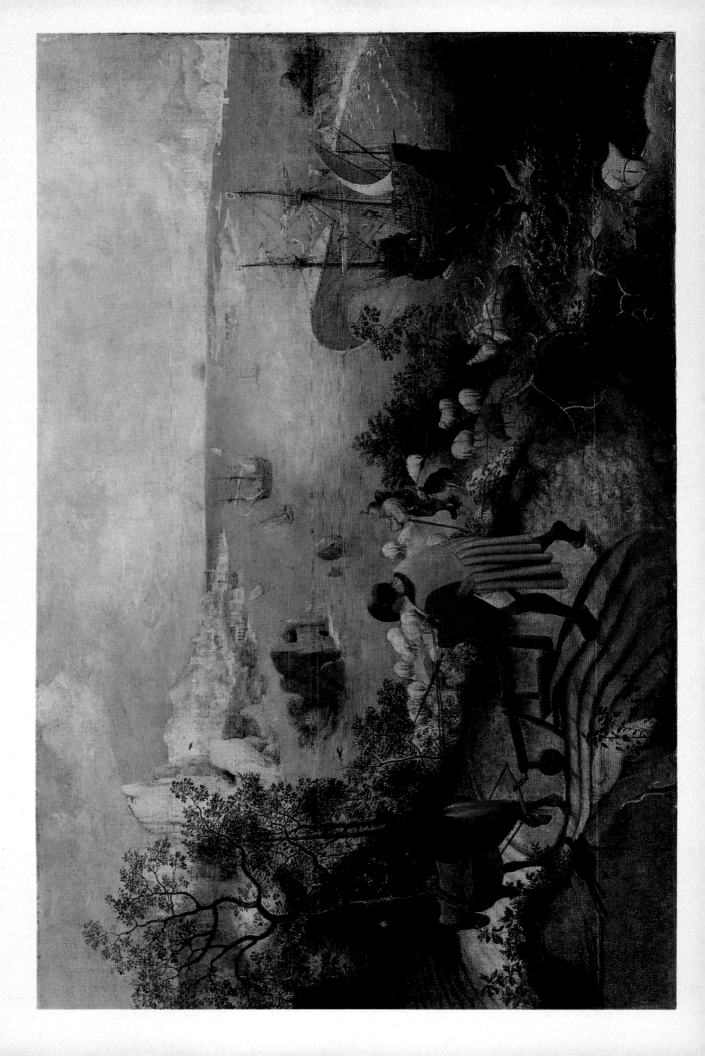

33. *The Wedding Feast*

$44\frac{7}{8} \times 64\frac{1}{8}in\ (114 \times 163cm)$

Probably painted in Bruegel's last years, this is one of his most famous masterpieces: deservedly so, for here some of the greatest qualities of his genius are fused to achieve their most exciting expression. His sense of composition, his wit and his acute powers of observation combine to make ever fascinating this marriage feast. Maybe he refers here to the sin of gluttony; but the picture is best appreciated for what it is: a feast to which children, the local lord (whose land the peasants work) and the neighbourhood monk have been invited. Memories of another wedding feast, that at Cana – the scene of one of Christ's miracles when he turned water into wine – are perhaps evoked by the innkeeper as he decants liquor for the expectant guests.

Vienna, Kunsthistorisches Museum

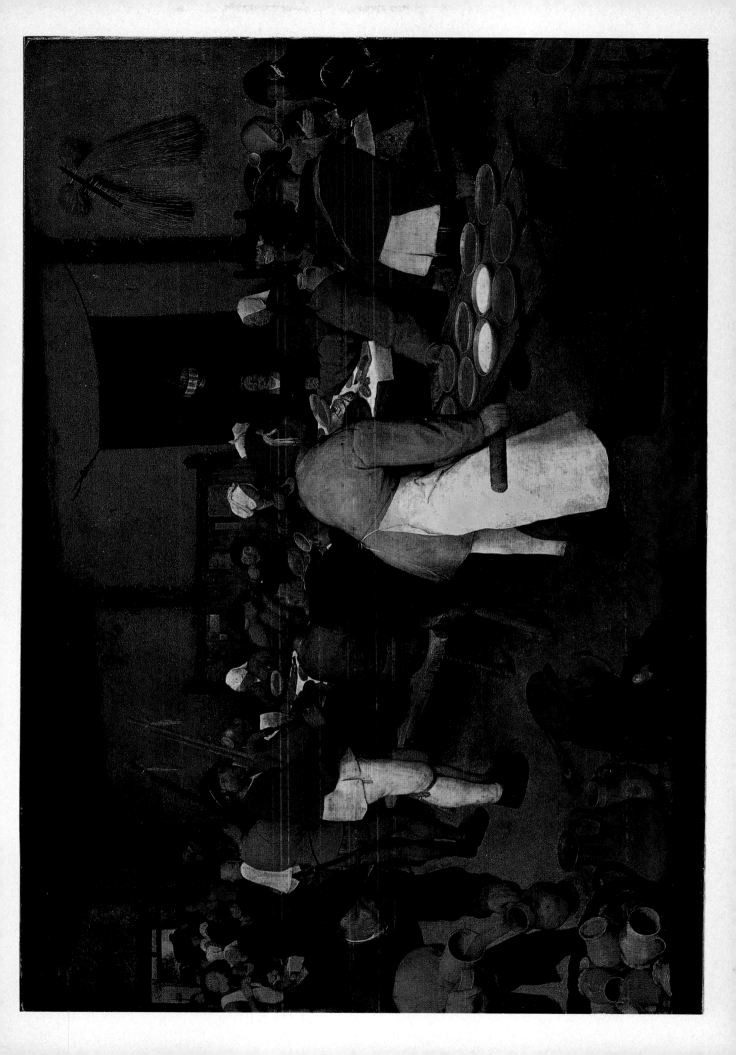

34. *The Peasant Dance*

Signed. $44\frac{7}{8} \times 64\frac{5}{8}$in (114 × 164cm)

Probably painted about the same time as the *Wedding Feast*, the *Peasant Dance* is less innocent in atmosphere, though just as closely observed. A fight seems to be about to start at the table, while the peasant in the foreground is abandoning the dance and running with his partner towards the inn. Beyond there seems to be a happy scene, but no good will come from the goings-on outside the inn.

Vienna, Kunsthistorisches Museum

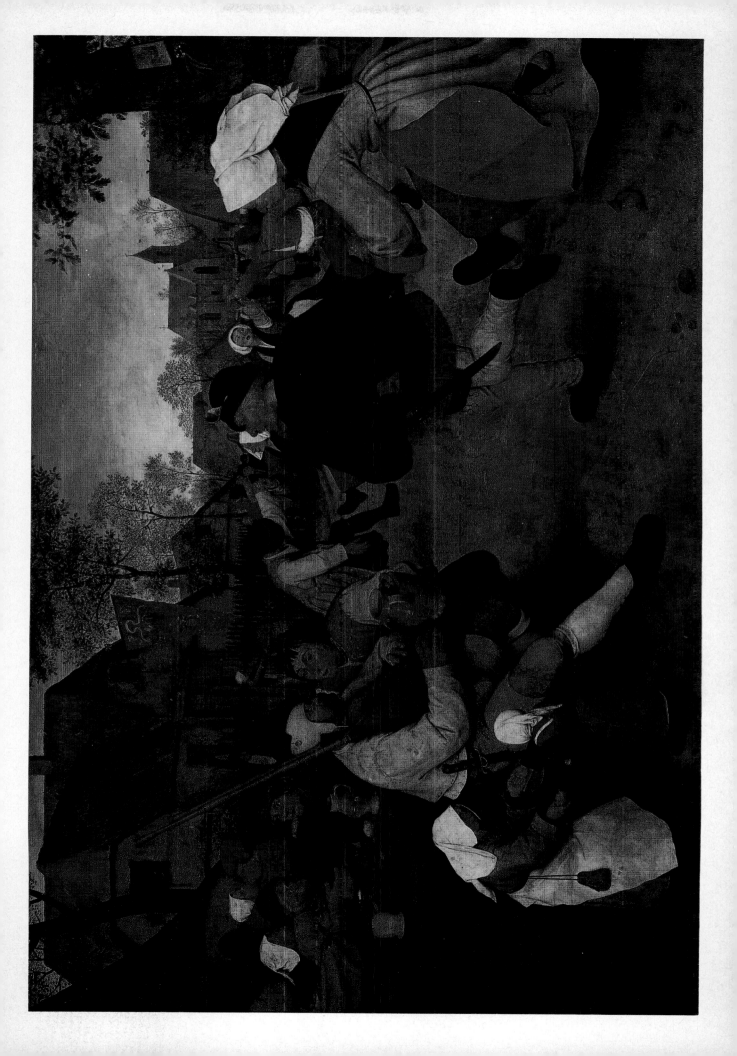

35. *The Lepers*

Signed and dated 1568. $7\frac{1}{8} \times 8\frac{1}{2}$in (18 × 21·5cm)

Five lepers have approached the entrance of a house; an old woman goes to the door (we imagine) with a begging bowl; bunched together the lepers await the outcome. They wear distinctive fox-tails, and three are adorned with paper party-hats that indicate Carnival time. Depicted close up and at their own level, the sight is not a pretty one; the concentrated realism betrays a sense of compassion: Carnival time it may be, but for the leper, begging remains his only form of sustenance, however energetically he capers or calls for attention.

Paris, Musée du Louvre

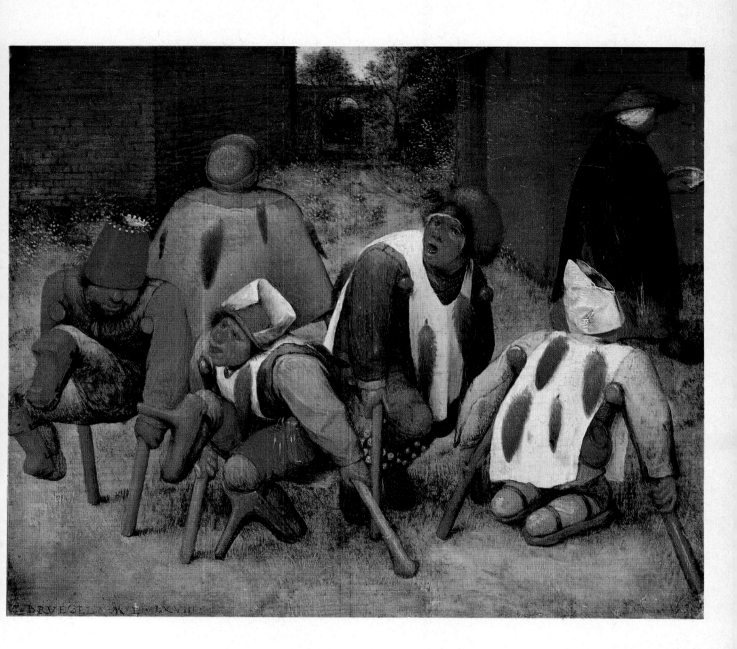

36. *The Parable of the Blind*
Signed and dated 1568. Canvas. 33⅞ × 60⅜in (86 × 154cm)

In the same year that Bruegel painted the five lepers at
Carnival time, he turned, on a much larger scale, to five
blind beggars to illustrate with haunting pathos the
parable 'If the blind lead the blind, both shall fall in the
ditch'. It is a deserted village, and the little band falls
inexorably into a painful mêlée of thrashing limbs –
painful, doubtless, but no more. It has been said, rightly,
that Bruegel here has created our image of poverty
wrought by blindness; and the haggard face with its empty
sockets that turns to us as he falls challenges our
consciences and asks us to consider the meaning of the
parable.

Naples, Museo Nazionale

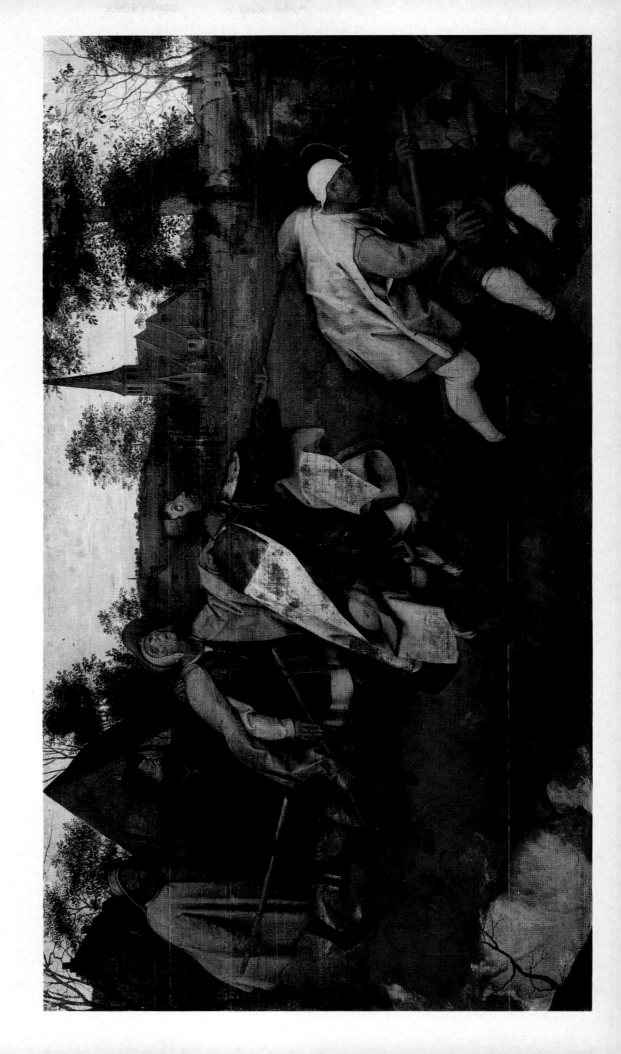

37. *The Misanthrope*

Signed and dated 1568. 33⅞ × 33½in (86 × 85cm)

The inscription explains the meaning of this strange, unsympathetic painting; it reads (in translation): 'Because the world is so faithless, I am going into mourning' (see Grossmann, *op. cit.*, p. 202, plate 144). It refers to the old man stumbling along, who is being robbed of his purse by a vivacious youth encased in a glass orb – a symbol of earthly vanity. Bruegel wishes to say in this late work that there is no way in which the wickedness of the world can be avoided.

Naples, Museo Nazionale

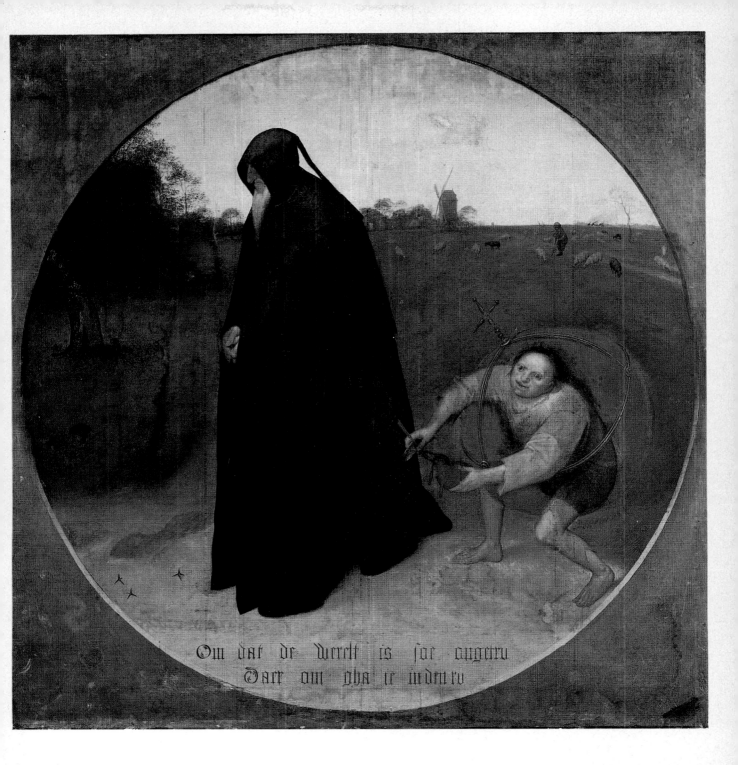

Om dat de werelt is soe ongetru
Daer om gha ic indenru

38. *The Peasant and the Birdnester*

Signed and dated 1568. 23¼ × 26¾in (59 × 68cm)

Like *The Misanthrope* of the same year, *The Peasant and the Birdnester* illustrates a proverb, and in telling it, Bruegel underscores the pessimistic moral that is to be drawn from it. 'He who knows where the nest is, has the knowledge, he who robs it has the nest' (see Grossmann, *op. cit.*, p. 202, plates 140–2). The peasant has the knowledge and is so concerned in pointing to the fact that he does not look where he is going: he is about to fall into the stream. The boy robbing the nest has already lost his hat and will probably lose his grip. Both, therefore, are disaster-bound.

Vienna, Kunsthistorisches Museum

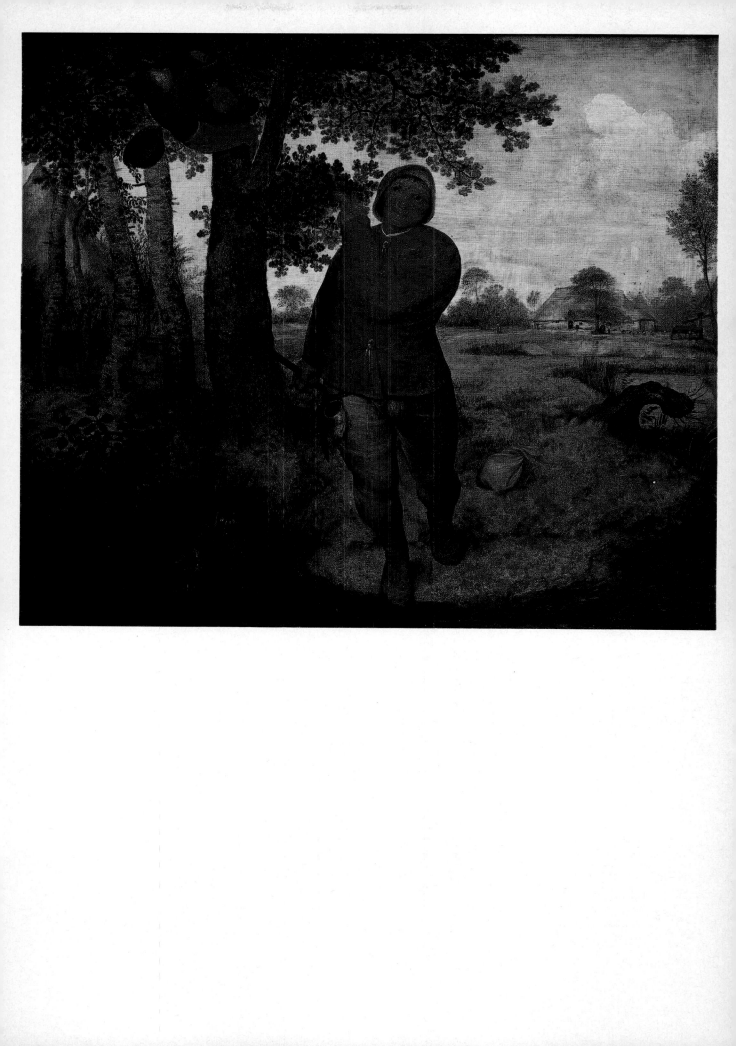

39. *The Magpie on the Gallows*

Signed and dated 1568. $18\frac{1}{8} \times 38\frac{1}{4}$in ($45 \cdot 9 \times 97 \cdot 2cm$)

This mysterious, exhilarating landscape may well be imaginary, a combination of different motifs seen long before it was painted. The village set among woods at the head of a valley dominated by rocky mountains was perhaps inspired by a memory of his journeys in the Alps. Perhaps, too, he had seen such a gallows as this on a sunset evening and watched the villagers dancing unconcernedly in celebration of some spring festival or rite. Who can know? What we do know is that Bruegel left this painting to his wife; in the magpie perched on the gallows, Bruegel alluded, so it is reported, to the gossips whom he would send to the gallows.

Darmstadt, Hessisches Landesmuseum

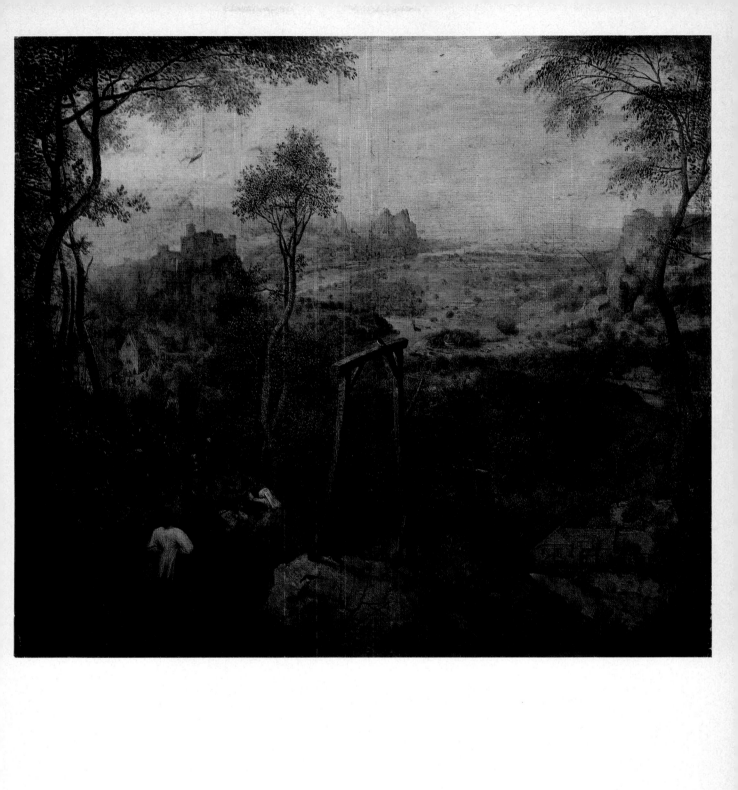

40. *A Storm at Sea*

$27\frac{5}{8} \times 38\frac{1}{4}in$ (70·3 × 97cm)

Generally, but not always hitherto unanimously accepted as the work of Bruegel, this dramatic depiction of a gale at sea may well have been unfinished and left in the studio when the artist died. Probably the first pure seascape in oils, it has also a moral to tell, which in a later rendering has been translated as: 'If the whale plays with the barrel that has been thrown to him and gives the ship time to escape, then he represents the man who misses the true good for the sake of futile trifles' (see Grossmann, *op. cit.*, p. 204).

Vienna, Kunsthistorisches Museum

Acknowledgements, and list of illustrations and sources

THE AUTHOR AND BLACKER CALMANN COOPER LTD would like to thank the museums and owners who allowed works in their collection to be reproduced in this book; unless otherwise stated they provided the transparencies used. The author and Blacker Calmann Cooper Ltd would also like to thank the photographers and photographic agencies who provided transparencies.

1. *The Fight between Carnival and Lent* Kunsthistorisches Museum, Vienna
2. *Detail of plate 1*
3. *The Netherlandish Proverbs* Staatliche Museen, Berlin-Dahlem
4. *Detail of plate 3*
5. *Children's Games* Kunsthistorisches Museum, Vienna. Photo Cooper-Bridgeman Library

6. *Detail of plate 5*
7. *A View of Naples* Galleria Doria, Rome
8. *The Suicide of Saul* Kunsthistorisches Museum, Vienna. Photo Cooper-Bridgeman Library

9. *The Fall of the Rebel Angels* Musées Royaux des Beaux-Arts, Brussels
10. *Two Monkeys* Staatliche Museen, Berlin-Dahlem
11. *Dulle Griet* Musée van den Bergh, Antwerp. Photo Cooper-Bridgeman Library

12. *Detail of plate 11*
13. *The Triumph of Death* Madrid, Prado. Photo Cooper-Bridgeman Library
14. *Detail of plate 13*
15. *The Death of the Virgin* Upton House, Banbury. Photo Cooper-Bridgeman Library
16. *The Tower of Babel* Kunsthistorisches Museum, Vienna. Photo Cooper-Bridgeman Library

17. *The Procession to Calvary* Kunsthistorisches Museum, Vienna. Photo Cooper-Bridgeman Library

18. *The Adoration of the Magi* Reproduced by courtesy of the Trustees, National Gallery, London

19. *The Month of January* Kunsthistorisches Museum, Vienna. Photo Cooper-Bridgeman Library

20. *The Month of February* Kunsthistorisches Museum, Vienna. Photo Cooper-Bridgeman Library

21. *The Month of July* National Gallery, Prague. Photo Cooper-Bridgeman Library

22. *Detail of plate 21*
23. *The Month of August* Metropolitan Museum, New York
24. *The Month of November* Kunsthistorisches Museum, Vienna. Photo Cooper-Bridgeman Library

25. *The Numbering at Bethlehem* Musées Royaux des Beaux-Arts, Brussels. Photo Scala
26. *St John the Baptist preaching* Museum of Fine Arts, Budapest. Photo Corvina Archives, Budapest

27. *Detail of plate 26*
28. *The Massacre of the Innocents* Kunsthistorisches Museum, Vienna. Photo Cooper-Bridgeman Library

29. *The Conversion of St Paul* Kunsthistorisches Museum, Vienna. Photo Cooper-Bridgeman Library

30. *Detail of plate 29*
31. *The Land of Cockaigne* Alte Pinakothek, Munich. Photo J. E. Bulloz
32. *The Fall of Icarus* Musées Royaux des Beaux-Arts, Brussels. Photo Cooper-Bridgeman Library

33. *The Wedding Feast* Kunsthistorisches Museum, Vienna. Photo Cooper-Bridgeman Library

34. *The Peasant Dance* Kunsthistorisches Museum, Vienna. Photo Cooper-Bridgeman Library

35. *The Lepers* Musée du Louvre, Paris. Photo Musées Nationaux
36. *The Parable of the Blind* Museo Nazionale, Naples. Photo Scala
37. *The Misanthrope* Museo Nazionale, Naples. Photo Scala
38. *The Peasant and the Birdnester* Kunsthistorisches Museum, Vienna. Photo Cooper-Bridgeman Library

39. *The Magpie on the Gallows* Hessisches Landesmuseum, Darmstadt. Photo Cooper-Bridgeman Library

40. *A Storm at Sea* Kunsthistorisches Museum, Vienna